LOUIS GAUFFIER

LOUIS GAUFFIER

This catalogue was issued as a limited edition of only 500 copies. It was produced in Turin and bound in Milan, Italy, to a design by Matthiesen Ltd. using *Burgo Chorus R4 Satin (Amadeus silk)* 200 Gsm soft fine art paper. It was printed on a *'Komori Lithone G40 Advanced'* press in five colours. Illustrations were printed using the dry proof method.

The typeface used for the title page is Garamond while that in the body of the text is based on the Perpetua Gill Family font designed by Eric Gill between 1925 and 1929 for Stanley Morrison, the typographical advisor to Monotype. Title headings are set in Mayflower Antique as well as the half title page.

The capitals and ornaments are set in ITC Golden Cockerell Capitals and Ornament font.

The cover is bound using Skivertex Sanigal 5300 Navy for the spine and Wicotex Toile du Marais Dahlia for the boards. The cover is blocked in silver using ITC Golden Cockrell font while the spine is set in Trajan.

The catalogue texts were written by ANNA OTTANI CAVINA and PIERRE STÉPANOFF.
Edited and translated by PATRICK MATTHIESEN and LAILA GABER.

Graphic design and layout by PATRICK MATTHIESEN.

Colour origination by Fotomec Srl. and production by Tipo Stampa.

The texts are © MATTHIESEN LTD.

Copyright reserved May MMXXII by MATTHIESEN LTD., LONDON.

ISBN 978-1-8383978-3-8

GAUFFIER

The Matthiesen Gallery
7/8, Mason's Yard, Duke Street St. James's,
London, SW1Y 6BU

MATTHIESEN LTD.

7/8, Mason's Yard, Duke Street St. James's,
London, SW1Y 6BU
Tel: (+44) 20 7930 2437 Fax: (+44) 20 7930 1387

E-mail: Gallery@MatthiesenGallery.com
Web: www.MatthiesenGallery.com

LOUIS GAUFFIER

La Cueillette des Oranges
(Picking Oranges)

LONDON
MATTHIESEN GALLERY
PUBLISHERS AND PICTURE DEALERS
MMXXII

In Memoriam

Renzo Parini
(1937 Milano - Torino 2022)

Typographer Extraordinary

PREFACE

My induction into the arcane world of typography and printing occurred quite by chance in my mid-teens when at Harrow School. The Technology and Engineering department, then hidden down an alleyway off West Street, had an annex at a different location on The Hill housing printing facilities. Those that were interested, and I was one of the curious, could learn the basics of printing at this facility. Apart from some ancient Caxton type handpresses there was also a Heidelberg Tiegel Windmill press (see Fig. 1). This had been donated by an old Harrovian Director of the great

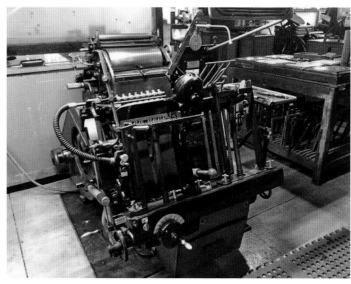

Fig. 1. Heidelberg Tiegel Windmill press.

British North Country printer, McCorquodale, who, among other things, carried out all the printing for the Post Office. The workings of this machine, developed circa 1914 and manufactured from cast iron, was a development of industrial age machinery and its methodology would still have been understood by Gutenberg if he had dropped in for a visit. I still can remember the mixture of smells on the print floor - paper, oil and ink. The machine, with a large flywheel, ran smoothly but emitted a most reassuring clattering noise indicating that it was doing its stuff. This was interspersed with the hiss of blasts of air sucked through nozzles which unfailingly picked up the sheets of paper and fed them into the rollers. The total effect was quite mesmerising.[1]

Almost twenty years were to pass before I once again became involved with printing. This took place at P & D Colnaghi and Company Limited in 1974 when, together with Michael Simpson and our secretary, a delightful English rose by the name of Verity, I became engaged in the compilation of a catalogue simply entitled *Paintings by Old Masters*. This modest paperback publication contained several major masterpieces the likes of which one may rarely see today. The catalogue included no less than Andrea Mantegna's *Christ Descending into Limbo,* Peter

1. An excellent American YouTube describes the machine here: A Goofy Guide to the Heidelberg Windmill, https://www.youtube.com/watch?v=vwyyTEl3fmU (but skip the advertisement).

Paul Rubens' *Oil Sketch of Peace Embracing Plenty* for the Whitehall ceiling, four Giandomenico Tiepolo's and two large paintings by Carlevaris which I had purchased in Monte Carlo, Giovanni Lanfranco's *The Widow of Sarepta Giving bread to Elijah* now in the Getty, a Pompeo Batoni, a Giulio Cesare Procaccini, *Martyrdom of Saint Agnes* and a ravishing work by Francisco de Zurbaran, *The Immaculate Conception,* and many other excellent works. The catalogue was printed in letterpress on a Heidelberg machine by the prominent publishers and printers, Lund Humphries. The fact that this catalogue contained three colour plates at this time was a major extravagance. If my memory serves me each plate cost around 600 pounds which at current value, since the pound has lost 91% of it's value in the intervening period, would equate to £5635 per colour illustration! There is clear logic as to why the commercial use of letterpress, with its metal plates and font and wood blocking, all of which were very labour intensive, has given way to offset litho printing. This is cheaper and faster, ten times more so than on letter press, and nowadays fully automated. Colour correction to a letterpress plate was an intensely skilled operation requiring an engraver and something that we now do on a computer terminal using software.

Back in 1974 fine art catalogues tended to be very simple. I can well recall sitting at a partner's desk on the first floor of Colnaghi dictating the catalogue with Michael Simpson to an angelic, patient woman from Lund Humphries, Ms Wilson, by name, whom I recall as being the living incarnation of Agatha Christies' Ms Marple in the eponymous TV series. Cataloguing consisted of artist's name, dates, picture title, size and maybe a line or two of provenance and to indicate an expert's opinion on dating. The process was quickly concluded within the hour. Yet this idyllic simplicity was soon to change. Auctioneers were beginning to produce ever more elaborate publications. At that time the marker for excellence in fine art cataloguing and expertise in print were catalogues produced by Andrew Ciechanowiecki's Heim Gallery[2], ably assisted by Alastair Laing. When I cut loose from Colnaghi, at the end of 1977, it was to these Heim Gallery catalogues that I looked for inspiration.

In 1981, having inaugurated my new gallery building, I embarked on an ambitious series of exhibitions which concluded in 2001. For these events we produced paperback catalogues, modest in format and somewhat akin to those at Colnaghi and Heim. I do not recall who provided me with the introduction, I believe it may have been Shaunagh Fitzgerald, who had also been at Colnaghi but later set up on her own as a

2. Andrzej Ciechanowiecki, Warsaw 1924-2015 London.

drawings dealer, but I met with Charles Mathew, the Managing Director of the de Montfort Press and Raithby Lawrence in Leicester. These printers traced their origin back to 1776 and had a large establishment operating several of the then latest *Komori* litho presses. Between 1981 and 1987 some fifteen of our catalogues rolled off these presses. In 1996, together with Stair Sainty, we embarked on a major project publishing a weighty tome entitled *Romance and Chivalry: History and Literature reflected in Early Nineteenth Century French painting*. So weighty was this book that it would have been prohibitively expensive to produce in Europe, so we outsourced the printing to the Print Room in Hong Kong, together with another catalogue that year. Much of what we saved in production costs we then spent in air freight shipping!

This was the same year that we produced one of our most memorable catalogues with the title *Gold Backs*. The catalogue accompanied our second major exhibition of early Italian paintings – the first had been a part loan exhibition in 1983. But this one was all from 'stock' and contained some amazing masterpieces. Inspired by the way Benson and Hedges had packaged their cigarettes in an all-gold box, I conceived a catalogue that was to look like a solid gold block with the page edges highlighted in crimson. I also required the best quality of colour printing available and had at the back of my mind the extraordinary quality of Franco Maria Ricci's (1937-2020) *FMR* magazine, then and since the epitome of colour printing. For this catalogue I turned to Umberto Allemandi, then in his heyday. He, in turn, introduced me to a printer in Turin to whose memory this catalogue is now dedicated. This catalogue was a thing of beauty but is sadly now out of print though available second hand on the internet. Today, the latest technology would allow us to print a metallised cover in gold, but back in 1996, after experimentation, we used a plasticised metallic foil. This caused the book binder endless heartache because it could not easily be bent to wrap the boards and at first refused to be glued securely. The following year we issued the first of three memorable catalogues entitled *An Eye on Nature* initially using the same printer.[3] By now I was hooked on the production of ever more lavish and innovative catalogue designs and bindings and had switched thenceforth to hard back publications. In part this was self-indulgence, in part it was a challenge, in part I conceived it as a defence against the ever more powerful auctioneers, and yes, in part, having dispensed with a graphic designer, it was to give me something to do!

3. *An Eye on Nature: Spanish Still Life Painting from Sanchez Cotan to Goya,* 1996.

The two catalogues printed in Turin in 1996 had proved rather expensive and so it was that when Leonardo Lapiccirella subsequently introduced me to Romano Binazzi at *Fiorepubblicità* in Florence, I started a relationship that was to result in a ten-year friendship, and the production of yet another fourteen hardbacked catalogues all with individual and elaborately conceived covers which challenged both printer, embosser, and binder. These were printed on KBA Planeta Rapida presses, a close cousin to the then current Heidelbergs but which now resemble Komoris. The second of *The Eye on Nature* series was dedicated to French Landscape painting and was covered in green baize with a cloth spine; others had elaborate foil or illustrative embellishment. This culminated in a weighty tome in 2001 which I had conceived to mark the turning of the millennium. Weighing in at almost three kilos this publication titled *2001 - An Art Odyssey 1500 – 1720,* a wordplay on the title of a once famous film starring the entrancing, young Jane Fonda, was not only silver foil bound but embossed in high relief with a special design, lavishly illustrated and even the black and white illustrations printed in quadro-tone, that is in four tints. By 2008, Romano Binazzi, who also coincidentally printed the catalogues for our tenant, Jean-Luc Baroni, probably exhausted by my excessive demands, decided to retire and raise his grand child so that the hunt for a new printer began once again.

Thinking to save the considerable international travel for design discussions and proofing the next two catalogues were printed in England by Pardy and Sons, but then I remembered my 1996 contacts in Turin and I approached the printer with some trepidation, remembering that Allemandi had always warned me that they were 'expensive'. Thus, it was that in 2009, with a major project in hand, the last of its kind that I shall ever indulge in, that I met up with Renzo Parini and this was the start of a close friendship interspersed with disagreement (!) which was to last until 2022. The 'project' was a lavish catalogue, far in excess of any previous publication that we had produced, to mark a ground-breaking exhibition of Spanish religious sculpture of the golden age, titled *The Mystery of Faith*. The exhibition was prepared with the collaboration of two Spanish colleagues, but the catalogue was a labour of love carried out entirely in London and Turin. Renzo rose to the challenge and with his knowledge of specialised techniques and his oversight the quality of the printing was superlative and has proved hard to equal ever since. Once again, the tome rivalled or exceeded *Romance and Chivalry* in bulk and weight. The printing cost some six figures and is not something I will ever attempt again. The postage cost an arm and a leg as well!

Renzo (Fig. 2) was a big man, tall, imposing, sometimes gruff, sometimes jovial. He was born in 1937 into a modest background in the small *frazione* of Arluno just outside Milan. His father was a *salumiere* – that is he ran a delicatessen or *charcuterie*. During the war, as a small boy, he would run errands distributing *panini* and sausages to the partisans. He grew up in an atmosphere of profound loyalty and dedication to others and with a sense for the ethics of plain hard work, tempered by an admiration and desire for that which he considered beautiful. Before he was called up for his National Service, as indeed everyone was for many years thereafter, Renzo had started to work in a pharmacy, but after starting his military service he also abandoned his studies. His military interlude took place in Turin. Renzo said these were carefree years but full of acquired experiences. It was at this time in 1958 that he had occasion to see the first ever exhibition of Francis Bacon in Italy at Mario Tazzoli's new *Galleria Galatea*.[4] Tazzoli had been a long-time friend of Giovanni Testori,[5] the Italian art historian, who had been a Bacon discoverer and enthusiast.

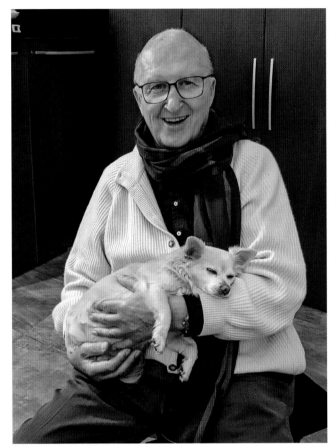

Fig. 2. Renzo Parini in 2021 with Billo.

The exhibition, which he visited on multiple occasions, left a deep impression on the young Renzo, and opened his eyes to both art and collecting. He would sit studying the Bacons wondering how it was that the rich Torinese were not buying these works, for Bacon at that time was little known. Throughout his later life he collected contemporary art, objects, sculpture, ivories, early crucifixes, vases, boxes. He had a particular passion for elephants and in fact collected more than 180 of them painted by artists from all around the world. These were later housed in his homes in Turin and Bordighera, but mainly in his office and all around the print factory walls.

Once Renzo had completed his military service, he took a job as an apprentice with a lithographer making plates for printing. His task was to drum up business and this he did during the day working nights making

4. Mario Tazzoli Rome 1921 – 1990 Milan.

5. Giovanni Testori Novate Milanese 1923 – 1993 Milan.

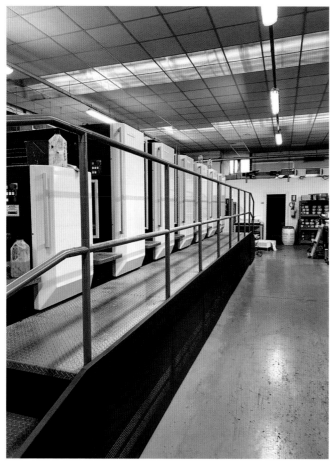

Fig. 3. Komori Lithone G40 Advanced.

plates. During this period, he only had time for one meal a day. By dint of sheer hard work by the mid 1960s he was able to start his own business. He immediately made contact with fine art publishers, Allemandi amongst them, and the artists themselves acquiring a reputation for high quality graphic work. The more he published fine art the greater his passion for collecting grew! Renzo had a generous nature, and he would often buy from young artists to help them or publish catalogues of their work and by doing this he accumulated a reputation as a specialist in fine art printing.

His son, Alberto, confided in me that he has no memories of his father as a normal parent taking him to a football match, but instead he remembers endless trips to art galleries and art fairs to look at art which also instilled in him a likewise passion.

Renzo set up a typographical and lithography business called *Star Fotolitho*, outside Moncalieri in 1963, together with a partner. From 1973, together with his mother, he bought out his partner and renamed the business *Fotomec*. Renzo carried out his printing though third-party suppliers but would always go down to the presses to see the result roll off the machine. His son tells me that such was his reputation and so scrupulous his demands for quality that when his dominating appearance appeared on the factory floor everyone would fall silent. He was renowned for requiring absolute quality and nothing less was acceptable. Often this would result in arguments with the machine operators and would end in Renzo instructing them exactly what to do to improve the quality and remedy defects. He never looked at the time sheet or took short cuts to restrain overheads – the end product had to be blemish free. This is one of the fundamental reasons why the two of us hit it off so perfectly. Renzo knew that I required his personal involvement – or nothing – and that I would never accept anything less than perfection. In this we were two peas in a pod, and I often made his life hell! His son, Alberto, joined the business after university in 1993/4. This was a period of major change in the industry caused by the advent of digital cameras and *Photoshop*

14

software. Realising that in order to survive he needed to expand, in 2005 Renzo acquired a rundown printing concern called *Tipostampa*. They immediately modernised both business, equipment, and premises to make it cutting-edge, with the intention of forming a business that was artisan in character but industrial in capacity. A relationship was formed with Komori and the business was honed until it was a state of the art printer second to none, constantly upgrading equipment. These last eleven years my visits there were frequent. Indeed, my last two catalogues were printed on a *Komori Lithone G40 Advanced* machine, the only one of its kind in Europe, and there is only one other machine outside Japan which is in the United States (see **Fig. 3**). This 'beast' is fifty feet long, can print 30,000 copies an hour and has the latest digital software and technology.

My memories of Renzo are punctuated by a lot of laughter and amusement, of provoking him to outbursts because I was never satisfied with results and always wanted more and better. But in this we were alike and respected each other. Renzo always said I was the most impossibly demanding client he had ever known, never satisfied, but he always rose to the challenge since he knew, and I knew that he knew, that our goal was the same – excellence. I fondly remember Renzo's acerbic humour and turn of phrase, his demands of his employees, some of whom had been with him for 20+ years, his inseparable love for his little dog, Billo, our trips to his club, the Circolo Caprera, where in the evenings he would play cards, and of course of our lunches in Ospedaletti at *Byblos* and on the quayside in Menton at *Marco's*, which has sadly closed and where Renzo would always eat fish, usually preceded by a platter of shellfish. Renzo passed away in March while we were in the middle of producing our last catalogue on Jusepe Ribera. He will be a very hard act to follow and I for one will miss him.

It was indeed at P. & D. Colnaghi and Co. that I first encountered Gauffier. Together with the renowned dealer Julius Weitzner we had purchased the *Four Views of Vallombrosa* (**Figs. 4 a,b,c,d**) which made a considerable impression on me. Two were subsequently sold to the Fine Art Museums of San Francisco in 1975 and one to the Philadelphia Museum of Art. The fourth was acquired years later by the Musée Fabre in Montpellier. A few years later, in 1985, here at Matthiesen, we purchased a small landscape which Pierre Rosenberg was to suggest was the work of Gauffier and we donated this to the San Francisco Museums. Many years were to pass until our next purchase which occurred by chance in 2009. I had missed bidding for the painting and a month or two later a French dealer, who had instead secured the painting, and not for the first time was lacking in the funds to actually pay for it much to the irritation of the *commisseur priseur* and *expert*, approached me in order

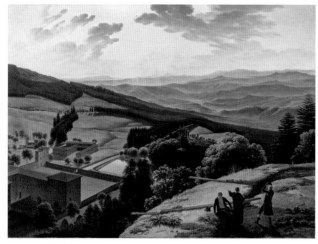
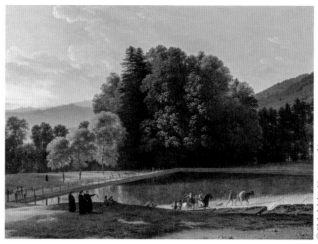

Figs. 4 a,b,c,d. L. Gauffier, *Two Views of Vallombrosa*, Philadelphia Museum of Art. W1975-1-1 and W1975-1-2.

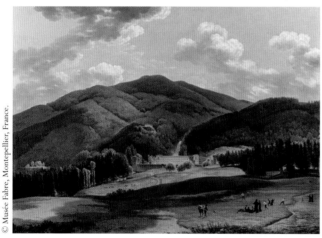
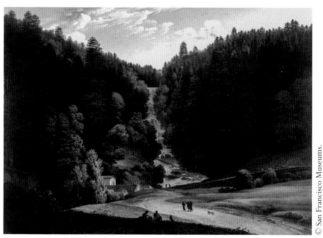

L. Gauffier. *Two Views of Vallombrosa*, Musée Fabre, Montpellier and Fine Arts Museums of San Francisco.

to ask if I would finance it in return for a half share. This I did and in 2010 I sold *La Famille Miot de Melito* to the National Gallery of Victoria in Melbourne (Fig. 5). This painting was one of the two multi-figure Florentine portrait masterpieces by the artist. The other, *La Cueillette des Oranges*, is the subject of this catalogue.[6] The

6. We can only surmise what it was that may have caused Gauffier to depart from more traditional portraiture and instead render this delightful 'conversation piece' which seems reminiscent of Johann Zoffany's work. Our painting 'epitomizes the essential requirement of a conversation piece, showing a group in a state of dramatic and psychological relation to one another.' (Sotheby's 10 June 2022 lot 63). Maybe he was inspired by Jean-Jacques Rousseau's writings on Nature. Indeed, in the early nineteenth century an edition was illustrated with an image of Camille Roqueplan's 1830s *Cueillant des cerises et les jetant à Mlles Graffenried et Galley*. Equally, was his use of red, white and blue drapery, as remarked upon by Pierre Stepanoff later in this publication, perhaps influenced by the 1789-1792 cult of *Les Arbres de la Liberté* adorned with tricoleurs?

setting for this conversation piece might well have been used to illustrate Johann Wolfgang von Goethe's *Italienische Reise* between 1786 and 1788, shortly before Gauffier reached Florence. This book was based upon reminiscences in his diaries. Goethe's earlier novel, *Die Leiden des jungen Werthers*, had made him celebrated throughout Europe and at the forefront of all the literary *illuminati*. Goethe was friends with several northern artists such as Angelica Kaufman, her husband, Antonio Zucchi, and Johann Heinrich Wilhelm Tischbein who painted his portrait, recumbent in the Roman Campagna. In his poem *Mignon,* Goethe penned the immortal lines 'Do you know the land where the lemon-trees grow…' followed in the next lines by 'in darkened leaves the gold-oranges glow, a soft wind blows from the pure blue sky.' One is tempted to believe that Gauffier might have known these lines as the inspiration for *La Cueillette* for although Goethe's *Italienische Reise* had to wait till 1816 to be published, his *Wilhelm Meisters Lehrjahre* (Wilhelm Meister's Apprenticeship) in which *Mignon* appears was published 1795-96 and thus may well have had an influence on Gauffier. Moreover, Goethe during his journey had shared friendships with Gavin Hamilton, painter, art dealer and archaeologist, friend, amongst others, of Canova and Piranesi, who in turn, at an earlier date in 1767, had corresponded with and befriended Johann Joachim Winckelmann. It was Winckelmann who had revived an interest in classical sculpture and whose teaching may have led to the inclusion of the Corinthian capital in our *La Cueillette*.

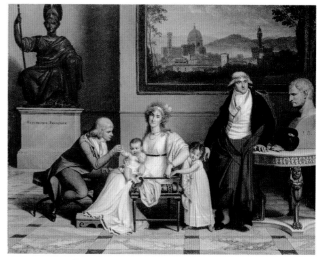

Fig. 5. L. Gauffier, *La Famille Miot de Melito*.

L. Gauffier, *La Cueillette*. (detail).

This catalogue, our 59th, is timed to coincide with the Louis Gauffier exhibitions held in 2022 in Montpellier and Poitiers. It could not have been put together in such short order after the recent publication of our catalogue *Ribera: A Roman Philosopher* without the assistance of Anna Ottani Cavina (Università di Bologna) and most particularly of Pierre Stépanoff (Curator at the Musée Fabre). We are so grateful to Anna and Pierre for their collaboration and their texts which are included in this small volume. The exhibition which they have jointly mounted in Montpellier is a total revelation. It is the first ever of its kind and a model of installation

and lighting and the wall labels are a lesson from which many institutions can learn. But above all Gauffier is revealed as an artist of far greater stature than has hitherto been presupposed - I would venture to state that his invention and execution far exceeds almost all paintings by Sablet and Fabre. Without having been a direct pupil of David, nevertheless, his figures are executed with incredible crisp precision and delicacy, the lighting is accurately observed down to the unique shadows of leaves on a brick wall or the surrounding stonework. He often manages to combine an historic sense of the classical antique with the then current neoclassic fashion of the Grand Tour. One of the most revealing things about the monographic exhibition is a realisation of Gauffier's greatness as a landscape artist.[7] This was already noted by his contemporaries, yet when one sees some of his *plein air* tree studies outlined against the clear blue sky, one can understand that here is an artist who occasionally already foreshadows the art of 1870-1900. Once he was settled in Florence and far from the restrictions of the French Academies in both Paris and Rome, Gauffier must surely have immersed himself in a study of the classical masters. Not just the great names of the High Renaissance, but also those luminaries of the so-called Primitive School, such as Masaccio and Beato Angelico. From the former he would have observed the new rules of perspective which were then later enhanced with fine attention to detail and sophisticated colour by the latter. Such a thought caused the writer to speculate that, just maybe, Gauffier knew Beato Angelico's gem *The Naming of St John the Baptist* (now in the Museo di San Marco) at first hand (Fig. 6). The painting was acquired by the Uffizi from Vincenzo Prati on the 20 September 1778 and is previously presumed to have belonged to the artist Ignazio Hugford, a cultivated collector of Primitives and a pupil of Domenico Gabbiani, the official Medici court artist. The Angelico hung in the Real Galleria initially where it was seen in 1795 by Luigi Lanzi who, according to Marchese in 1854 (*Memorie Dei Più Insigni Pittori, Scultori E Architetti*), commented admiring it as *'il più gaio e finito'* among the artist's *'quadretti di stanza'*. This snippet of information is, of itself, of interest because Hugford not only was intimately connected with the conservation of the Vallombrosa abbey but also actually executed more than 14 religious works for that location between 1740 and 1760. During these same years he had formed a notable collection which was a compulsory destination for foreign cognoscenti, and his art dealing activities involved both Horace Mann and William Kent, and in 1755 Robert

7. This was also recently highlighted by Carole Blumenfeld in her review of the Montpellier exhibition in the July 2022 edition of the *Gazette de l'Hotel Drouot*, No. 26 01 July 2022 where she wrote: *'Les œuvres de Gauffier étonnent toutefois par leur singularité et leur présence….Dès lors qu'il fit choix de regrouper ses effigies sur une seule toile, (as in Orange Picking/La Cueillette) Louis Gauffier les pensa ensemble, ou plutôt comme un ensemble. Les portraits….présentent de vagues similitudes entre eux, mais en le regroupant, Gauffier en dit long sur son approche du genre….Sa force est bien dans sa façon unique de saisir la gestuelle de ses sujets. Le peintre d'histoire, qui a étudié le nu pendant des années, regarde leur façon d'évoluer dans l'espace. La tension des corps, la position des hanches, et le mouvement des bras sont bien plus importants pour lui que les traits des visages, si ressemblants soient-il. C'est éloquent avec ses portraits d'officiers français en Toscane, qui adoptent la même pose standardisée, mais dont le rendu des portraits est absolument hétérogène.'*

Adam and Charles-Louis Clérisseau. The Treccani dictionary states '*Il suo nome era celebre nell'Italia del grand tour non solo per la brillante attività di art dealer*'. Indeed, together with Thomas Patch, he was one of the very first to re-evaluate the Primitive School. I mention this because among the other connoisseurs who frequented his salon were none other than Gauffier's acquaintance, Gavin Hamilton, but also Pierre-Jean Mariette. Hugford died in August 1778 well before Gauffier's arrival in Tuscany. His collection first passed to his nephew and then between 1779 and 1782 it was dispersed. Why this discourse on Hugford? It serves to demonstrate just how international both society and collecting taste was in the Florence of this period. Moreover, the connection with Adam, Kent and above all Hamilton lead me to surmise that among Gauffier's contacts there may have been an individual who pointed the

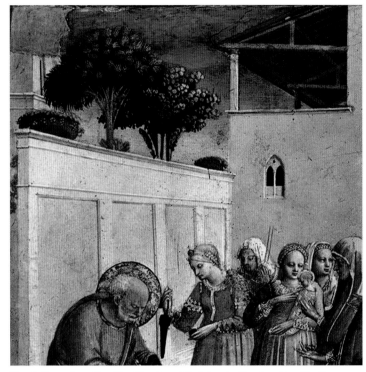

Fig. 6. Beato Angelico, The Naming of St John the Baptist, (detail), Florence, Museo di San Marco.

young Gauffier towards a study of the Primitives, their clarity of light, the careful developments of constructing space, the attention to minutiae and detail and above all colour. If so, it seems entirely feasable that he knew Beato Angelico's *Naming* at first hand and in consequence its use of flowerpots on a wall, a delightful feature of 'object staffage'. Flowerpots, of course, are everyday objects and feature in neoclassical art. Benoit used one to warn her husband if the Revolutionary police were at hand, Catel features them. But the prominence accorded them by Gauffier in his *Portrait of Guillame Joseph Coclers Van Wyck* where they serve to frame the right side of the sitter while accentuating the recession of space is remarkable. I have allowed myself the guilty pleasure of conjecturing that just possibly Gauffier was aware of this distant precedent.

The cover this time is bound in French *Toile de Marais Dahlia* orange coloured cloth so as to form a link with the subject of the painting. It should be noted that it is improbable that the 'oranges' being harvested are the fruits as we know them today. Bitter oranges used for making marmalade were commonly planted in northern Italy because they are more frost resistant (*Citrus aurantium var. aurantium*). These were originally native to eastern Africa, the Arabian Peninsula, Syria, and Southeast Asia but are now grown throughout the Mediterranean. It

is probably a cross between the pomelo, *Citrus maxima*, and the mandarin orange, *Citrus reticulata*. Gauffier does not allow us to identify the identity of the fruit with certainty as the oranges are too small in the painting but there are two further alternatives. There is a variety called '*Pernambuco*', which is quite delicious and which is common throughout Liguria having been imported from near Recife in Brazil in the eighteenth century. This would fit well with the Gauffier. An alternative identification which is, perhaps, the most likely is that these are not actual oranges but Mandarins which again are grown in Liguria and Northern Tuscany; smaller and sweeter than oranges, a little flatter in shape, as indeed they appear in the painting, they have a thinner, looser skin that makes them easier to peel. They were commonly planted in gardens in the nineteenth century and probably earlier.

Once again we particularly wish to acknowledge our gratitude to Michel Hilaire (Director of the Musée Fabre) for permitting and facilitating the sharing of texts from the catalogue of the exhibition and for allowing the writer to have the invaluable collaboration of Pierre Stépanoff, to whom we also express our thanks for his collaboration and essay. No publication on Gauffier is complete without the invaluable contribution of Anna Ottani Cavina, who has dedicated a lifetime of study to the artist. We also thank Marcella Culatti (Fondazione Zeri) for photographic assistance, Marie Fischer, Giulia Giustiniani, Aymeric Rouillac for detailed information about the provenance, Jennifer Thompson (Philadelphia Museum of Art), Gerard Vaughan, Christian Vignaud (Musées de Poitiers). As always we acknowledge Tim Watson and Carole Willoughby for conservation and Bruce Francis and Paul Mitchell for a heads-up on framing terminology and particular thanks to our Gallery manager, Laila Gaber, for all her organisation and assistence.

<div align="right">

PATRICK MATTHIESEN
JUNE 2022

</div>

LOUIS GAUFFIER

1762-1801

La Cueillette des Oranges (Picking Oranges)

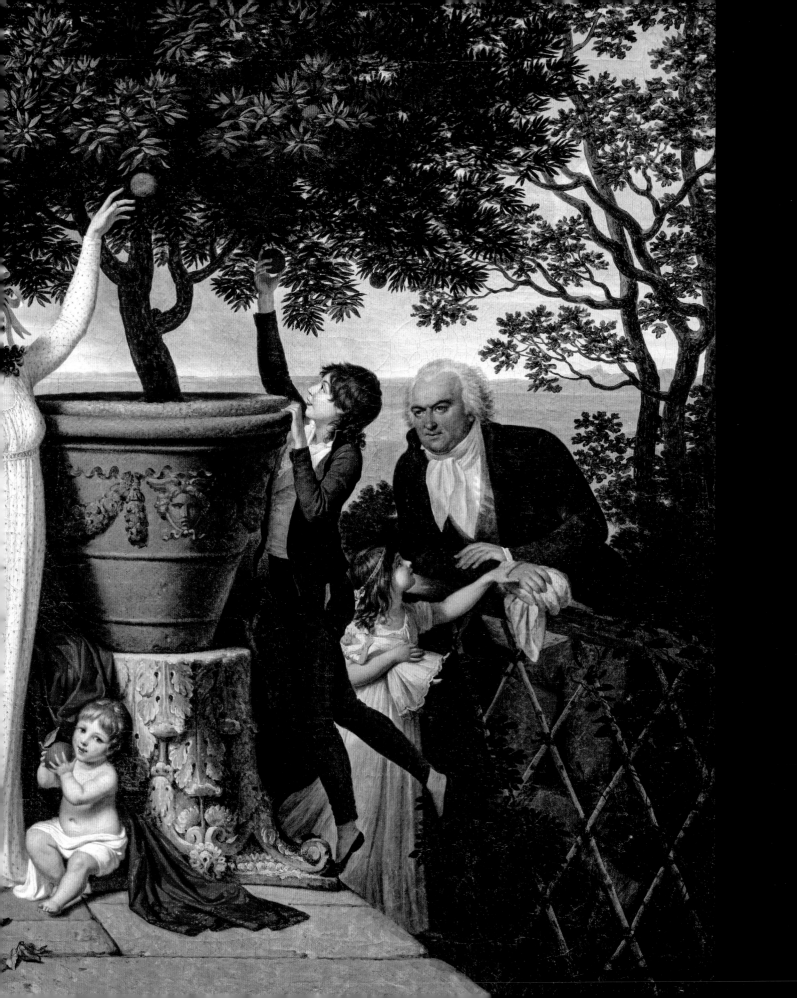

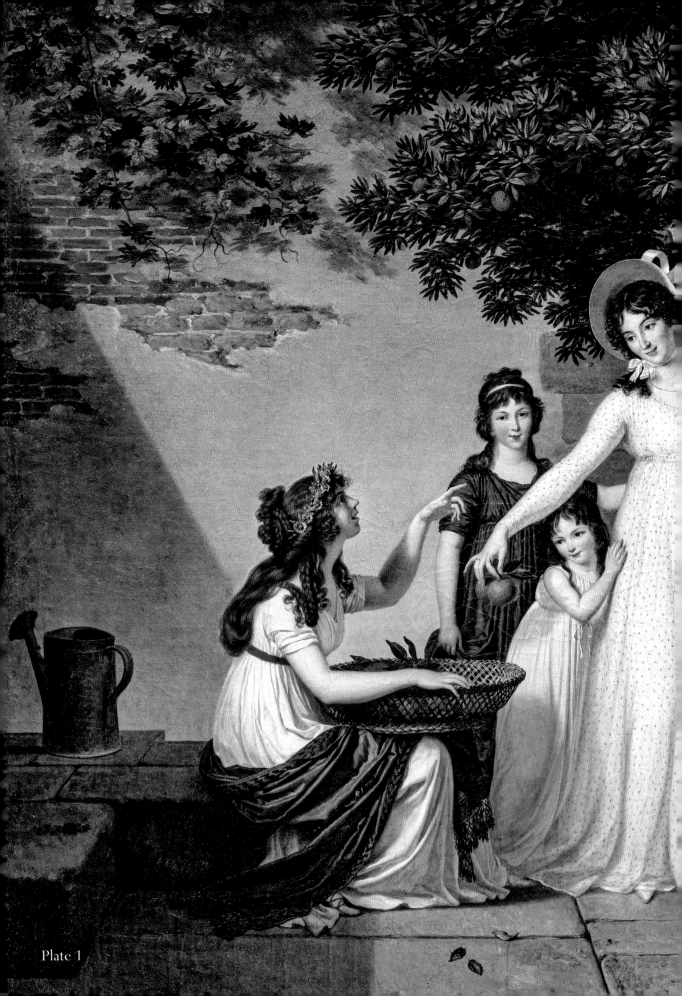

Plate 1

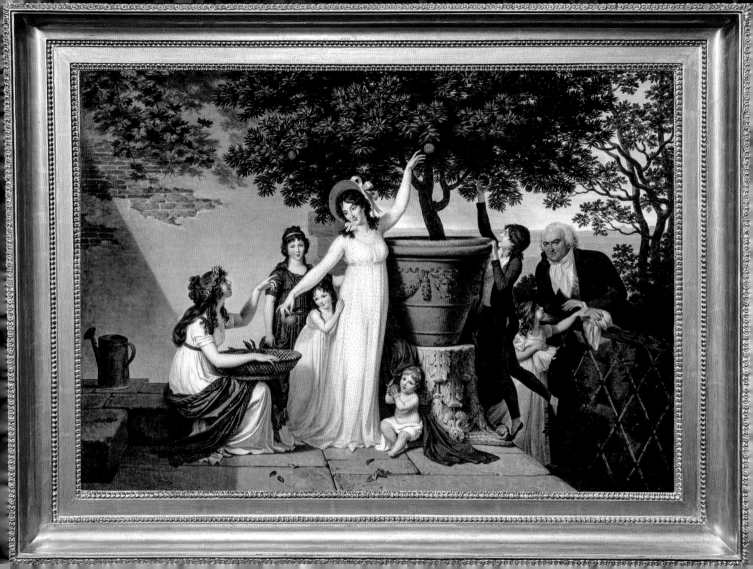

LOUIS GAUFFIER

Poitiers 1762 - Florence 1801

La Cueillette des Oranges (Picking Oranges)

Oil on Canvas: 69 x 99 cm

PROVENANCE:

Alexandre Marie Gosselin de Sainte-Meme, 1746-1820;
1784 married in Marseille Anne Élise Henriette d'Assailly, 1770-1859.

Anne Joséphine "Laurette" Gosselin de Sainte-Même, 1788-1829 ;
1808 married in Naples Amand "Robert" Denis de Senneville, 1777-1851.

Geneviève Alexandrine "Mélanie" Denis de Senneville, 1812 – 1888;
1834 married in Anizy-le-Château Léopold Michel Martial, baron d'Azemar, 1804-1888.

Adolphe Henri "Gaston" d'Azemar, 1837-1921;
1870 married Louise Annaïs Massing 1849-1916.

Léopoldine d'Azemar 1871-1944;
1894 married in Bourg-en-Bresse, Félix Marie Centenier de Fauques, 1851-1932.

Philippe Centenier de Fauque, 1895-1963 ;
1920 married in Rochefort, Christine Limouzin, 1895-1975.

Thence by descent until 2020.

EXHIBITED:

Montpellier, Musée Fabre, 7th of May 2022 – 04th of September 2022, *Le Voyage en Italie de Louis Gauffier*, pages 344-345; Musée de Poitiers, 14th of October 2022 – 12th of February 2023, *Un Voyage en Italie, Louis Gauffier (Poitiers, 1762- Florence, 1801)*, pages 344-345.

LITERATURE:

Anna Ottani Cavina and Emilia Calbi, *Louis Gauffier Un Pittore Francese in Italia*, Silvana Editoriale (Fondazione Federico Zeri), 2022, catalogue number R25 pp.224-225, figure 78, page 112.

' CE CLASSICISME, … COMME BASE D'ENSEIGNEMENT, NE POUVAIT QUE FAVORISER UN TALENT OU
SE MONTRAIT DEJA DU GOUT, DE LA FINESSE.
MAIS, AVEC TOUS NOS CONTEMPORAINS, NOUS LUI PRÉFÉRONS CE NATURALISME
SAIN ET NUANCÉ DONT GAUFFIER A TIRÉ UN PARTI MERVEILLEUX DANS SES PORTRAITS '

<div align="right">P. MARMOTTAN</div>

' IL FAUT QUE JE VOUS PARLE DU SALON, GAUFFIER A EXPOSÉ UN PETIT TABLEAU QUI EST
CHARMANT ET SURTOUT ÉTONNANT POUR LE RENDU, C'EST COMME DE LA MINIATURE. LE PAYSAGE
EST FAIT COMME UN ANGE'.

<div align="right">JEAN-GERMAIN DROUAIS</div>

'LE VOILÀ DONC ENFIN CE CHEF-D'ŒUVRE DE GAUFFIER ! RAPHAEL, ET POUSSIN ET LESUEUR NE
ROUGIRAIENT PAS D'AVOUER CE TABLEAU'.

<div align="right">LA BEQUILLE DE VOLTAIRE AU SALON</div>

'J'AI REMARQUÉ, ENTRE AUTRES, UN PETIT TABLEAU DONT LE SUJET EST JACOB ET RACHEL, PAR UN
JEUNE ARTISTE NOMMÉ GAUFFIER. LES FIGURES ONT SIX POUCES DE HAUT; ELLES SONT GROUPÉES AVEC
GOÛT, BIEN DESSINÉES ET DU PLUS BEAU COLORIS. LE PAYSAGE SEMBLE FAIT PAR UN ARTISTE
DE PROFESSION; AUCUN TABLEAU D'HISTOIRE NE M'EN A OFFERT DE SEMBLABLE…'

<div align="right">C. GESSNER</div>

LOUIS GAUFFIER
1762 - 1801

There are few events to mark Louis Gauffier's short life span. He was born in Poitiers on the 10th of June 1762 and was later apprenticed to the Paris studio of Hugues Taraval. He won the *Prix de Rome* in 1784 jointly with Jean-Germain Drouais.[1] On the 20th of November that same year Gauffier arrived in Rome, almost contemporaneously with Jacques- Louis David, who had returned to the city in order to paint his large canvas depicting the *Oath of the Horatii*. All the artists who were then present in the city gravitated around David.[2] François-Guillaume Ménageot was then the current director of the Academy. With a bursary to study at the Academy Gauffier was assured of a residency of four years in which to carry out his studies. He trained as a history painter despite the fact that Ménageot had noted, right from his earliest days there, that Gauffier's pictorial inclination was 'unsuited to the painting of large-scale figures'.[3]

In 1788 the artist made a three weeklong trip to Naples. This was intended to broaden his studies and subsequently he was granted a further six-month extension to his residency at the Académie de France. His *Jacob and Rachel* (1787, Paris, Louvre) and *Alexander and Hefaistíon* (1789, Florence, Pitti) date from these years. A brief trip to Paris between June and December 1789 was curtailed due to the dramatic events of the French Revolution. This resulted in a consequent lack of work so that Gauffier consequently made a hasty return to Rome on the 15th of December. In March 1790 he married his pupil, Pauline Chatillon, who was a painter of intimate genre scenes. From this time onwards, until his death, Italy became Gauffier's country of adoption.

1. On account of the fact that the prize had not been awarded in 1779, exceptionally there were two prizes available for award in 1784.

2. Those artists specialising in landscape painting have recently been studied by Anna Ottani Cavina — see *I Paesaggi della Ragione*, Torino 1994.

3. Montaiglon – Guiffrey, *Correspondance des Directeurs …*, vol. XV, p. 49.

The first reference to the artist's presence in Florence, however, is recorded in a communication dated 26th of April 1793 sent to François Cacault, the French diplomat present in Rome.[4] Immediately thereafter, on the 3rd of May, he was received (*agréez*) as a member of the local Accademia di Belle Arti. Gauffier had been obliged to leave Rome, together with a number of other artists, as a consequence of the assassination of Hugou de Bassville, the Secretary of the legation on the 13th of January 1793. This bloodstained event was the most dramatic event resulting from a revolt by the Roman Populus against French rule and Bassville's outspoken criticism of the Vatican. This, in particular, served to direct ire against the Académie de France.

Nicolas-Didier Boguet, the Sablet brothers and Bénigne Gagneraux were all supporters of the Republican revolutionary movement, whereas François-Xavier Fabre and Louis Gauffier were decidedly anti-revolutionary and pro-British, attaching themselves to the latter's political and intellectual circles.

As a result of Gauffier's connections, both to Frederick William Hervey, the son of Lord Bristol, and with François-Joachim de Pierres, cardinal of Bernis, both of whom were sympathetic to the *ancien régime,* Gauffier was subjected to an aggressive literary attack in the publication *Società repubblicana e popolare delle Arti*.[5]

Gauffier's move to Florence had the consequence that he was compelled to change the subject matter of his paintings since, having lost the protection of the Académie, he was obliged to find local patronage. No longer a pure history painter he became instead a landscape artist, as may be seen by his series of views inspired by the Tuscan abbey at Vallombrosa, where Gauffier spent the summer of 1796, and while drawing and painting *en plein air,* he also became a prolific painter of portraits. His four views of Vallombrosa, all of which are fully signed and two are dated 1797, are now located in the Musée Fabre in Montpellier, Philadelphia Museum of Art and San Francisco Museum of the Legion of Honour. These four views of Vallombrosa represent the apogee of the artist's study of nature and had previously all been located in Glenstal Abbey, in the county of Limerick, on the Irish Atlantic coast.

Even when he had been executing history paintings at the Académie de France in Rome, his ability to depict landscape in the background of his subjects had been noted. In 1787 Conrad Gessner sent a letter to Father Salomon in which he lauded the quality of Gauffier's background landscapes: 'amongst other things I have noted

4. F. Boyer, *Le Monde des Arts en Italie et la France de la Révolution et l'Empire*, Turin, Società Editrice Internazionale 1969.
5. J. Lapauze, *Société populaire et républicaine des arts*, 1923, pp. 201-202.

a small painting depicting Jacob and Rachel. It was painted by a young artist called Gauffier… The landscape would appear to have been executed by a landscape specialist; I cannot recall anything similar in another history painting'.[6] Jean-Germain Drouais, also a *pensionnaire* at the Académie and both a friend and a rival, was forced to admit 'the landscape would appear to be painted by an angel'.[7]

Political events had obliged Gauffier, and many other artists, to flee Rome and once established in Florence he frequented an international circle of Grand Tour cosmopolitan tourists many of whom frequented the circle of the poet Vittorio Alfieri and his companion, Louise de Stolberg, Countess of Albany. Paintings dating from this period include The Portrait of *Gustaf Maurits Armfelt,* 1793 (Stockholm National Museum), *The Portrait of the Duke of Sussex*, 1793 (Karlsruhe, Kunsthalle), the *Portraits of Lady Holland* and *Lord Holland*, 1794, the *Portrait of the Painter Van Wyck Cockers*, 1797 (Montpellier, Musée Fabre) and the *Portrait of Thomas Penrose*, 1798 (Minneapolis Institute of Arts).

Compelled to become a portrait painter by financial necessity Gauffier revealed his ability in depicting his subjects in a very personal and modern manner with refined talent. His portraits are almost always signed and dated. The precision and detail of his portraiture influenced both his contemporaries and those active during the later period of the Restoration. When compared to the heroic, large-scale portraits by David, Gauffier instead adopts a smaller scale with a more sentimental setting for his figures, a formula also adopted by Jacques Sablet. Whereas the revolutionary period set its portraits against a backdrop, Gauffier's figures are instead inserted into both a natural and intimate surrounding which results in figures being situated both in interiors and typical Italian landscapes. This new formula met with wide success and led to a rapid succession of commissions which only began to slow down in 1799, a critical year of Napoleonic conflict. Shortly after this interlude Gauffier again increased his output but, with the return in October 1800 of the French to Florence, his patrons thereafter became both French soldiers and diplomats residing in Italy, or those foreigners passing through Florence.

Gauffier's life ended dramatically. In July 1801 the artist lost his beloved wife and in consequence on the 20th of October he also died prematurely at the age of 39 in the city of Florence.

6. A. Montaiglon – Guiffrey, *Correspondance des Directeurs de L'Académie de rance A Rome*, vol. XV, 1787, p. 171, n. 8839.

7. P. Marmottan, *Le peintre Louis Gauffier*, Gazette des Beaux-arts, 1926, p. 285

A report in *Le Moniteur Universel* on the 19th of November 1801 (28 *Brumaire*, An X, p. 230) which is cited by Marmottan[8] has led one to believe that Gauffier died in Livorno, but in reality, he died in Florence as subsequently stated in the obituary section of the *Moniteur Universel*.[9] On the 19th and 20th of May 1802, the contents of the artist's studio were sold in the courtyard of the Louvre in Paris.[10] This auction was organised by the sculptor Antoine-Denis Chaudet and the painter Léonor Mérimée to benefit Gauffier's two young, orphaned children whom he had assigned to the tutelage of the painter Fréderic Desmarais.

ANNA OTTANI CAVINA

8. P. Marmottan, *Le Peintre Louise Gauffier*, Gazette des Beaux-arts 1926, p.298, Paris.
9. 11 Germinal An X, p. 766; cfr. Ottani Cavina - Calbi, 1992, p. 32
10. C.P. Landon, *Annales de l'Art Français* Vol. II 1802, p. 209.

CHRONOLOGY

Courtesy of Musée Fabre, Montpellier, France.

9 June 1762
Louis Pierre Gauffier is born in Poitiers, son of Louis Joseph Gauffier, stonemason, and Catherine Burgaud.

10 April 1779
Gauffier is first reported in Paris aged 17. He attends classes at the Royal Academy and the studio of Hugues Taraval. He wins the third class medal, for a figure drawing. He takes part in the Prix de Rome for painting in 1782 and 1783.

28 August 1784
Gauffier wins first prize for the year 1779, put in reserve, while his competitor Jean Germain Drouais, David's favourite student, wins first prize for the year 1784.

10 October 1784
Gauffier departs for Rome with the winners of the prix de Rome for sculpture and architecture. He arrives on the 25th of November and settles at the Palazzo Mancini, home of the French Academy in Rome. Drouais, accompanied by his master David, had already arrived in the Eternal City in early October.

August 1785
David leaves Rome after painting *The Oath of the Horatii*, assisted by Drouais. After showing it to the Roman public, he unveiled it in Paris at the Salon in the same year.

25 August 1786
At the Palazzo Mancini exhibition, Gauffier exhibits his first history paintings. This small salon exhibition by the king's boarders is commented on with interest by the Roman and international public. Gauffier would successfully exhibit there every year.

28 August 1787
In Paris, the young native of Montpellier, François-Xavier Fabre wins the first prize for painting before travelling to the city of Rome.

13 February 1788
Drouais dies. Upset, his comrades erect a monument to him in the church of Santa Maria in Via Latta.

October 1788
Gauffier visits Naples during a three-week stay.

28 April 1789
Gauffier, on reaching the end of his time as a boarder, leaves Rome for Paris.

5 May 1789
Opening of the Estates General in Versailles.

14 July 1789
The storming of the Bastille in Paris.

24 August 1789
Gauffier is presented to the Royal Academy of Painting and Sculpture. He is admitted on the condition that he paints his reception piece.

25 August 1789
Opening of the Salon where Gauffier exhibits three paintings.

16 December 1789
Gauffier, who has left Paris in a hurry, returns to Rome.

17 April 1790
Marriage to Pauline Châtillon (1772-1801) who is from a French family based in Rome.

25 August 1791
Birth of Louis, the Gauffier couple's first child.

September 1791
Six works by Gauffier are exhibited at the Paris Salon.

16 August 1792
Birth of Faustine, the Gauffier couple's second child.

22 September 1792
Proclamation of the Republic in Paris, deposition of Louis XVI.

3 May 1793
Gauffier is appointed professor at the Florence Academy, alongside Fabre. He quickly amasses a rich clientele of European tourists he portrays.

September 1793
Tuscany joins the European coalition against France.

15 January 1794
In front of the Popular and Republican Society of Arts, in Paris, Jean-Baptiste Wicar, a former student of David, denounces Gauffier and Fabre as traitors to their country and demands the cancellation of their Prix de Rome award. The assembly rejects this proposal, thanks to David's intervention.

27 July 1794
Fall of Robespierre in Paris, end of The Terror.

9 February 1795
Restoration of diplomatic relations between France and Tuscany.

2 March 1796
General Bonaparte takes command of the Italian army. He defeats Piedmont in April, then enters Parma, Milan and Modena in May.

30 June 1796
Bonaparte spends a few days in Florence. Gauffier may have painted a portrait of the young general on this occasion.

August 1796
Gauffier goes to the Vallombrosa Abbey to produce studies and sketches for a commission of four landscapes. He would work for another year before delivering this cycle, his masterpiece, in 1797.

2 February 1799
After much tension throughout 1798, France declares war on Tuscany. Florence is occupied from 25 March to 20 July. The Austrians then take possession of the city.

8 and 9 November 1799
The Coup of 18 Brumaire by Napoleon Bonaparte. Beginning of the Consulate regime in France.

28 May 1801
In a letter addressed to his friend, the painter Castellan, Gauffier tells of the serious respiratory disease which is afflicting him and his wife.

27 July 1801
Pauline Gauffier dies in Florence, aged 29.

20 October 1801
Louis Gauffier dies in Florence, aged 39. He leaves behind him two orphans, Louis and Faustine, who are cared for by his friends, the painter Frédéric Desmarais and the sculptor Antoine Chaudet.

November 1801
Fabre gathers a rich collection of paintings, sketches, studies and drawings from his friend's studio. The Portrait of the Gauffier family is bought by the Tuscan administration to enrich the Uffizi Gallery's collection.

19 and 20 May 1803
First sale in Paris from the Louis and Pauline's studio at the Louvre, organised by the Société des Amis des Arts.

27 and 28 June 1803
Second sale and dispersion of the works from Gauffier's studio.

5 January 1825
By offering a large part of his personal collection to the City of Montpellier, Fabre founds the museum that today bears his name. There are twelve paintings by Gauffier in this donation. This gift was complemented by a bequest in 1837, including twenty drawings and studies by Gauffier. These generous acts have preserved the memory of the artist in Montpellier for nearly two centuries.

LOUIS GAUFFIER
LA CUEILLETTE DES ORANGES

THE ACADÉMIE ROYALE IN PARIS

Certain pictures may appear familiar although, in fact, one has never seen them beforehand. This is the case with the portrait of the Gosselin de Sainct-Même family, which is one of the most ambitious compositions ever attempted by Louis Gauffier. A reduced version of the picture has been located in the Chateau de Versailles since 1850 (Fig. 1). Thus, we have been aware of the existence of this long-lost eight figure composition situated on a sunny terrace, where the protagonists are engaging in gathering oranges from a tree. The reappearance of this picture on the French art market in 2020 now means that we may at last fully appreciate the delicacy of expression with which this family group is portrayed as well as the tender, smiling, playful nature of the characters. Gauffier's life spanned an era of radical political transformation that consequently influenced both his life and art. In 1784 Gauffier was the winner of the Royal Academy of Painting and Sculpture's '*Grand Prix*'. In the 18th century, all young painter's

ambitions centred on the Grand Prix de l'Académie Royale. After several qualifying tests finalists were invited to present a painting on a subject chosen by the Academy members. This was to be taken from a story in the Bible, Greek or Roman history or mythology. The laureate then was awarded a paid residency at the Académie in Rome for a period of four years. This training period allowed artists to study ancient and modern masterpieces, while at the same time ensuring the promise of prestigious commissions upon their return to Paris.

For the 1784 Grand Prix, the jury selected a passage from the Gospels - the Canaanite woman at the feet of Christ. Gauffier, then aged 22, was one of the most

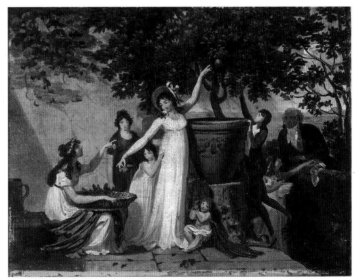

Fig. 1. Louis Gauffier, *Portrait de la famille Gosselin de Sainct-Même* (miniature), 1797-1798, oil on canvas mounted on board, 11,5 x 15,6 cm, Versailles, musée national des Châteaux de Versailles et de Trianon, inv. MV 4851.

promising candidates. Trained in the studio of Hugues Taraval (1729-1785), he had won prizes for life drawing in 1779 and 1780 and then competed for the Grand Prix in 1782 and 1783. Among his follow competitors, Jean Germain Drouais was undoubtedly the great favourite. His master, Jacques Louis David (1748-1825), who in only a few years had become the most celebrated painter at the Parisian Salons, held his young pupil in very high esteem. At the end of March 1784, the candidates were admitted 'into the lodge' where they patiently worked on their painting.

In August 1784, once the test was completed, Drouais was proclaimed the winner, but the jury also chose to honour Gauffier with a prize for 1779, which had not been awarded that year. Their serious, majestic paintings demonstrated the very clear influence exerted by the art of Antiquity, but above all by that of the paintings of Nicolas Poussin (1594-1665), both then considered perfect models. The two young men were paraded triumphantly by their comrades and left France in October in order to travel to the Eternal City.

Rome was a truly 'European Academy' or artistic laboratory where painters and sculptors developed new forms of art. Gauffier lived in the Palazzo Mancini at the very heart of the city, on via del Corso. This was the seat of the Académie de France. The residents spent much of their time practising the study of the nude form under the guidance of two successive directors, Louis Lagrenée (1725-1805) and François Guillaume Ménageot (1744-1816). Most importantly, they had plenty of time to explore the city, its monuments, remains, public museums and private galleries. Copying was at the very heart of their education, and this allowed the artists to build up a rich repertoire of models during the four years of their stay which then they could use throughout their careers.

ROME AND THE PALAZZO MANCINI

David had accompanied Drouais to Rome and the French pupils filled their albums with hundreds of drawings, delivering their own personal a new vision of the city. Their observations of contemporary Rome and its inhabitants, dressed in heavy cloaks and luxuriant draperies, imitated the perfect majesty of ancient sculpture.

Gauffier's early development at the Palais Mancini was wholly engaged in developing history painting.[1] During their four years of residence at the Palazzo Mancini the residents were subjected to strict rules, forced to work only for the king who was financing their sojourn. However, Lagrenée and Ménageot, the two directors, allowed some exceptions. Each year, between 1784 and 1789, Gauffier painted history pictures. Presented annually at the residents' exhibitions on the 25th of August, which was St. Louis' Day, they were admired by the Roman public with great enthusiasm. French art-lovers visiting Rome bought the works so allowing the young man to make a name for himself. Over the years, Gauffier and his friend Drouais became the two most promising talents of the French school.

In his history paintings Gauffier followed the neoclassical trend then prevalent in European painting. Ancient sculpture and architecture, the classical painters of the Renaissance and the 17th century, Raphael, Nicolas Poussin and Eustache Le Sueur were all then considered perfect models and suitable inspiration for a budding young artist. Among those living painters, David, who had stayed in Rome between 1775 to 1780 and once again from 1784 to 1785, appeared as the true leader of this new aesthetic movement. Since Gauffier had not been his student he distanced himself from the master. Violent action and warlike subjects are absent from his art and instead his Old Testament paintings are set in radiant landscapes that express an idyllic, pastoral and somewhat primitive sensibility. These compositions, inspired by ancient history, show a limitless archaeological curiosity, a learned taste for objects and furniture, and above all a graceful refinement of execution.

A BRIEF RETURN TO PARIS

Fragile health compounded by the Roman climate regularly got the better of the painter, who suffered from fevers, headaches and respiratory ailments. During the winter of 1787-1788 Gauffier and Drouais were both seriously ill. Drouais died on the 13th of February 1788 at the age of 24, while Gauffier recovered. This tragic death distressed all the residents, but also served to place Gauffier in a dominant position. Having

1. Louis Gauffier's career may be studied in the monograph and the catalogue published in 2022: Anna Ottani Cavina, Emilia Calbi, *Louis Gauffier, Un Pittore Francese in Italia*, Milan Silvana Editoriale 2022 and Michel Hilaire, Pierre Stepanoff (editors), *Le Voyage en Italie de Louis Gauffier*, exhibition catalogue, Montpellier, musée Fabre, 7 May- 4 September 2022, Gand, Snoeck, 2022.

reached the end of his internship at the Académie, Gauffier then returned to Paris in April 1789. He was to take part for the first time in the Salon and so expose his art to the Parisian public. On the 24th of August, the day before the opening of the exhibition, he presented himself so as to ascertain whether the Academy members would permit him to join that Institution. With the opening of the Estates General on the 5th of May, the Tennis Court Oath on the 20th of June, the storming of the Bastille on the 14th of July and the final abolition of privileges on the 4th of August, the French Revolution erupted at this very same moment. The nobility, who constituted the regular clientele for the artists, fled Paris and emigrated abroad. This collapse of art patronage convinced Gauffier to return to Rome on the 16th of December; he was never to return to France.

Throughout the Revolution, political debate and collective values of the time were sympathetic to the to classical culture and more particularly the history of the Roman Republic. On the 7th of September 1789, a delegation of women artists, painters and sculptor's wives (amongst them Mmes David, Suvée, Lagrenée, Vien, etc.) had travelled to Versailles to offer their jewels to the Assemblée Nationale in order to help bail out the public debt. These 'virtuous citizens' were, in effect, re-enacting an episode from ancient history, in which the Roman women had offered their finery to the Republic. His attention drawn to these events, Gauffier then painted *The Generosity of the Roman Women*, (Fig. 2) which he sent and exhibited at the Salon in 1791. Both a sense of civic dedication and those exemplary virtues of Antiquity that artists had illustrated since the 1780s now aligned themselves with the most burning current political issues.

'Unaccustomed to large-scale painting', as Lagrenée put it, Gauffier always preferred small format works, which he created for a dedicated clientele of private art lovers. Whether he painted on canvas or wood panel, these small paintings reveal his skill as a miniaturist, his fine touch and his delicate taste. These paintings differ from the monumental compositions painted by David, his emulators, and his students. They reveal instead a particular penchant for a tender and loving register, where a sensitivity of feeling responds to that of the preciosity of the brush. His repertoire was not limited only to the dramas of Greek and Roman history. Instead Gauffier also enjoyed representing the amorous mythologies of Ovid, the Latin poet and author of the *Metamorphoses*. He also drew upon subjects from *Jerusalem Delivered*, the epic poem by Torquato Tasso (1544-1595), an Italian Renaissance writer, who wrote many courtly stories describing the first crusade. The idylls and pastorales of the Swiss poet Salomon Gessner (1730-1788), a precursor of Jean-Jacques Rousseau, inspired him to create new subjects. The meditations of Bernardin de Saint-Pierre (1737-1814), with his contemplative view of nature, also awakened in Gauffier an interest in allegory. All these literary inspirations helped to define a gentle, sensitive, tender, and sincere form of art.

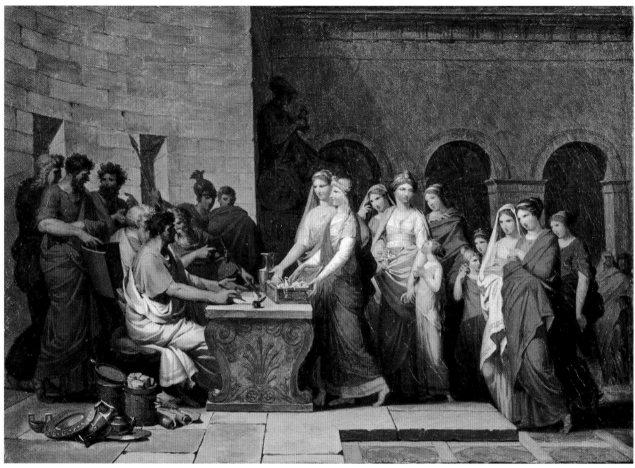

Fig. 2. Louis Gauffier, *The Generosity of Roman Matrons*, 1790, 82 x 113 cm, oil on canvas, Poitiers, Musée Sainte-Croix.

The most loyal of all Gauffier's Roman clients was undoubtedly Thomas Hope (1769-1831). Born into a family of Scottish bankers in the Netherlands, Hope was the heir to a family of great art lovers. The young man was indifferent to business and from 1787 to 1799 made many journeys throughout Europe and the Mediterranean These took him to Italy, as well as Greece, Anatolia and Egypt, three regions that were difficult to access and rarely visited at the time. He bought many works of art, both Greek and Roman sculpture, mummies and Egyptian canopic vases, as well as paintings by both the great masters and also those of living artists. In the early 1790s it was in Rome that Hope had first met Gauffier, from whom he commissioned six paintings. Hope undoubtedly passed on to Gauffier an interest in decor, furniture, and antique accessories, as well a curiosity which reached beyond Rome to ancient Greece and the Egypt of the pharaohs. In 1799, Hope settled

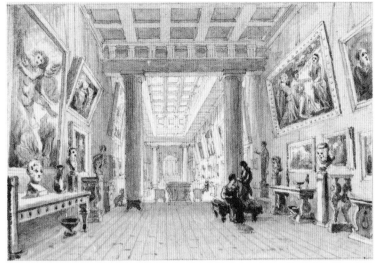

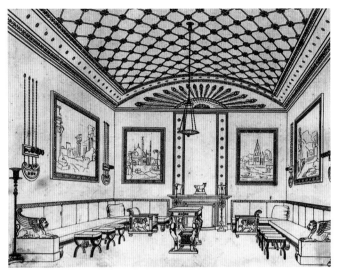

Fig. 3a. William Henry Bartlett, *Interior of Thomas Hope's Picture Gallery, Duchess Street, London*, 1825-54, ink on paper, 6.7 x 10.2 cm, New York, The Elisha Whittelsey Collection, The Elisha Whittelsey Fund, 1963.

Fig. 3b. Thomas Hope, *Illustration from Household Furniture*, 1807, drawing.

in London and purchased a house in Duchess Street which he completely refurbished. Each room, which he designed himself, was adorned with a particular style of decor to accommodate the different parts of his collection (Figs. 3a and 3b).

Meanwhile the painter had also become involved with a young girl from a French family living in Italy, Pauline Châtillon. He had trained her to paint as his pupil, and he subsequently married her in April 1790. Pauline also specialised in genre painting. Her work, which is still relatively unknown, depicts figures of the people of Rome in folk costume. Behind an apparently prosaic tone, her subjects always combine nostalgia for the simple life with a moral lesson.

THE RETURN TO ITALY, FLORENCE, AND THE GRAND TOUR

The French Revolution convinced Gauffier to return to Rome and he established himself in Italy for the remainder of his career. The intensification of the Revolutionary events in France also had repercussions among the French residents in Rome, culminating in two violent riots in January and February 1793.

Louis and Pauline Gauffier were forced to flee and settle in Florence, accompanied by Gagneraux, Sablet and François-Xavier Fabre, the winner of the 1787 grand prix. Now cut off from his native country and considered both an emigrant and a traitor to his homeland, Gauffier's career radically changed; originally destined for large State commissions, he now was compelled to doing business with travellers from all over Europe during their Grand Tour of Italy. While originally specialising in history painting, he had also become the official portrait artist of this cosmopolitan clientele. While Europe went to war with France, neutral Tuscany was a peaceful haven for these travellers. Throughout the 18th century, travel to Italy had become obligatory education for this mostly British elite. During their long stay, these travellers discovered ancient ruins and monuments, built up a collection, and met socially during balls and salons. Far away from their country of origin this was an opportunity to complete their intellectual education, and at the same time engage in new encounters and even love affairs. Gauffier was privileged to witness these social encounters. For this clientele, anxious to retain memories of their trip, he developed an original portrait format, influenced both by Sablet as well as by English painting, in which the models appear full-length but within the confines of small intimate paintings. In a clever mixture of elegance and relaxation, they pose in landscapes, enlivened by the monuments of Florence such as the Palazzo Vecchio and Brunelleschi's dome. By placing these models within landscapes that combined the monuments of the Tuscan capital and the beauty of nature, he developed a formula mixing intimacy and charm with informality. He often painted in the open air (*en plein-air*), studying trees and rocks, atmosphere and light. These he then transposed into his landscapes with an extraordinary sensitivity that heralded the inventions of the 19th century. Although a student of David, François- Xavier Fabre becomes completely influenced by his friend Gauffier and adapts his own portraits to these innovative formulas.

THE FRENCH RETURN TO ITALY

The lightning success of Napoleon Bonaparte's 1796 campaign heralded the return of the French to Italy and the consequent departure of the English milords. Thus, Gauffier had occasion to obtain access to a new pool of clients, those French officers, diplomats and administrators transiting through Florence. Occupied in 1799 and then in 1800, Tuscany had gradually become the satellite of France. Gauffier reconnected in this way with his compatriots who were all anxious to have their portraits painted and to retain the memory of their mission or campaign in Italy. The painter skilfully eliminated any form of military rigour, instead

offering an attractive synthesis or blend of the traditional informality of the Grand Tourist while at the same time incorporating the colourful elegance of the revolutionary uniforms. Gauffier also tried his hand adapting the typically English genre of the Conversation Piece, which features several characters, posed naturally in a setting while at the same time illustrating family values.

PICKING ORANGES AND THE ART OF PORTRAITURE

The date of our picture, signed **L. Gauffier / Flor.ce an 6e / de la Rep.e** , written in accordance with the revolutionary calendar, indicates that this picture, representing French subjects, belongs to this precise historic moment of transition having been painted between September 1797 and September 1798. Research carried out by Aymeric Rouillac has now allowed us to identify the individual figures in this painting which hitherto had been anonymous.[2] Alexandre Marie Gosselin de Sainct-Même 1746-1820, stands on the extreme right. Born in Paris in the middle of the XVIII Century he had married the young Anne Henriette Elise Assilly ,1770- 1859, who was 24 years his junior. He held a position as an administrator or Quarter Master of all military supplies for the army in Italy throughout the revolutionary wars. Later, he was appointed French Consul General to the Kingdom of the Two Sicilies. It seems certain that it was while he was fulfilling this role that he ordered the family portrait from Gauffier. The couple can be seen surrounded by their five children: to the right, Alexandre Henri, born in 1786 and thus then 11 years old. The 9-year-old Adèle Honorine approaches her father while holding a doll. Anne Joséphine wearing a blue dress stands to the left of the composition, beside her youngest sister, Antoinette Françoise, who is 7 years old. In the foreground little Charlotte Alexandrine who is only two years old, plays with an orange. The only child who is missing in this composition is Eugène Maurice who was born two years later. We are not aware of the identity of the woman who is seen in profile on the far left. She may well be a certain Rosalie, who was a family friend, then acting as a governess, and who later, according to a statement by the duchesse d'Abrantès, took the veil. The wife of General Junot recalls that during her youth in the 1790s, she had occasion to meet this family and recalls the event in her memoirs. She describes there the lively scene for which Gauffier's painting is an almost perfect illustration:

2. Aymeric Rouillac, « Réunion de la famille Sainct-Même sous le Directoire », *Rouillac, 2020,* <*https://www.rouillac.com/fr/ news-2458-reunion_famille_sainct_meme_sous_directoire*>.

'In Paris my mother met a family from Marseille with whom she became very friendly. M. Madame de Sainct-Même were the best and most excellent of friends. M de Sainct-Même was in charge of the supplies for the army in Italy. He was rather old to be the spouse of his young wife who was a delightful individual. She loved him with so much tenderness and affection that he might have been the most handsome young man about town in Paris. Both her virtue and her innocence made her a truly interesting personality. I feel a warm sense of happiness just remembering my memories of her. When I recall this young mother surrounded by six or seven children, all of whom she had nursed while also carrying out her household duties while among them, I experience a feeling of calm which refreshes my blood. Carrying out this activity she could have been a young Greek woman in classical times in a Gynoecium.'[3]

We do not know what led to a meeting between the artist and his models. The signature informs us that the painting was executed in Florence. It must be there that the commission was given because there is no record of Gauffier leaving Tuscany from the time of his arrival in 1793 until the date of his death in 1801. In consequence it was probably Sainct-Même himself who commissioned the artist while transiting through the Tuscan capital. Whereas Anne Henriette, her children and her friend occupy a major part of the composition, Sainct-Même is placed to the extreme right. The artist clearly wanted to suggest the distancing of the father from the rest of his family. Is it possible that his wife and children were then living in Naples? Or maybe they had stayed in France thus, obliging Gauffier to imagine the majority of his models? The facts as we know them today do not allow us to conclusively answer these questions. Nevertheless, the isolation of Sainct-Même who seems to be imagining this joyful family scene from a far rather than actually participating in it, enhances the composition with a particularly moving poetic sense of intimacy. Gauffier is here trying to emulate the English genre of the conversation piece, a type of portraiture commonly used by English painters during the XVIII Century. While continuing to utilise the characteristics of genre painting, the inclusion of so many figures creates an almost narrative theme. Such late XVIII century English painters as Gainsborough and Reynolds had revitalised a style of painting whose ambitious compositions combined an astonishing sense of novelty, while at the same time including a feeling of grandeur which had once been traditionally the reserve of a Royal clientele (Fig. 4). While still maintaining a dynastic spirit or clannish feeling represented by the children, these artists also managed to introduce a sense of intimacy or complicity between the figures on account of the natural characteristics of their poses, costumes and occupations. Then, so as to reinforce this sense of spontaneity, the

3. Laure Junot, duchesse d'Abrantès, *Mémoires de Madame la duchesse d'Abrantès, ou Souvenirs historiques sur Napoléon : la Révolution, le Directoire, le Consulat, l'Empire et la Restauration*, Paris, Ladvocat, 1831, t. II, p. 98-99.

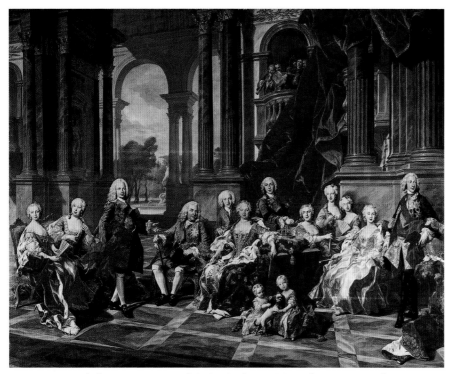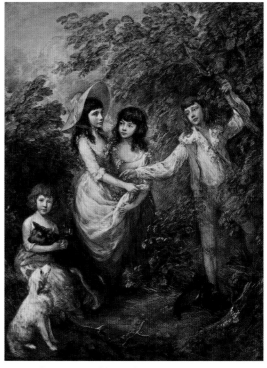

Fig. 4. Louis Michel Van Loo, *Portrait of the family of King Philip V of Spain*, 1743, oil on canvas, 408 x 520 cm, Madrid, musée du Prado, inv. P002283.

Fig. 5. Thomas Gainsborough, *The Marsham Children*, 1787, oil on canvas, 243 x 182 cm, Berlin, Gemäldegalerie, inv. 82.4.

artist integrated his subjects within the natural framework of landscape (Fig. 5). This new type of imagery is the culmination of a profound transformation that had been developing throughout the century and which resulted in the Enlightenment. The emergence of certain bourgeois values highlighted the ideal of a united family and well-maintained household. This particularly focused on the liberty and well-being of children, a concrete and tactile expression of the tenderness existing between them and their parents. This trend, which, perhaps, had been born in England, focusing on filial love or childish spontaneity, had simultaneously begun to find a certain success in France as reflected in the paintings of Boilly. This may well have been partly due to the influence of Jean-Jacques Rousseau and the cult of innocence and simplicity which he was then propounding.[4]

In his *Portrait du jeune Paulin des Hours-Farel*, painted in 1793, Antoine Jean Gros is a notable example of this trend (Fig. 6). From the 1780s onwards, Gauffier would have been aware of portraits painted by the Irish artist

4. For this subject see Christine Kayser (éd.), *L'Enfant chéri, au Siècle des Lumière*, exhibition catalogue Louveciennes, musée Promenade Marly-le-Roi, 10 July – 12 October 2003, Paris, L'inventaire, 2003.

Fig. 6. Antoine Jean Gros, *Portrait of Paul François known as Paulin des Hours-Farel*, 1793, oil on canvas, 74,5 x 98 cm, Rennes, musée des Beaux-Arts, inv. 70.46.1

Fig.7. Jacques Sablet, *Portrait of a family in front of the Basilica of Maxentius*, à Rome, 1791, oil on canvas, 60 x 72 cm, Lausanne, musée cantonal des Beaux-Arts, dépôts de la Fondation Gottfried Keller, Office fédéral de la culture, Berne, 1932, inv. 739.

Hugh Douglass Hamilton or, indeed, by the Swiss artist, Angelica Kauffman. While he had resided in Rome both these artists had incorporated a sense of family intimacy and the joys of the domesticity in the household into their paintings.[5] Certainly, he would have been able to appreciate the intimacy and charm of family portraits executed by another Swiss artist Jacques Sablet. Here the small scale of the canvases broke away from the tradition of the formal, rhetorical portrait so as to promote a sense of imagery which was both natural and sincere (Fig. 7).[6] It was, in fact, Sablet who had synthesised both the grandeur and majesty of the traditional Grand Tour Portrait, such as those painted by Pompeo Batoni and Von Maron, with the tradition of the family 'conversation piece' as represented by those small scale, intimate and sensitive images, which were often the hallmark of 18th Century English painting. Gauffier had already experimented with this formula sometime prior to his adoption of the format as a business model. An early example was the intimate portrait painted

5. Anna Ottani Cavina precisely documents possible meetings between Gauffier and Hamilton, which took place in the circle of Lady Ann Flaxman. See Anna Ottani Cavina, Emilia Calbi, *op. cit.*, p. 94. On the subject of Hamilton, see Anne Hodge (éd.), *Hugh Douglas Hamilton (1740-1808) : a Life in Pictures*, exhibition catalogue Dublin, National Gallery of Ireland, 22 November 2008 – 15 February 2009, Dublin, National Gallery of Ireland, 2008.

6. With regard to this artist see Anne Van de Sandt (editor), *Les Frères Sablet (1775-1815), exhibition catalogue Nantes, musées départementaux de Loire Atlantique, 4 January-10 March 1985, Lausanne, musée cantonal des Beaux-Arts, 21 March-12 May 1985, Rome, musée de Rome – Palazzo Braschi, 21 May-30 June 1985, Rome, Carte Segrete, 1985.*

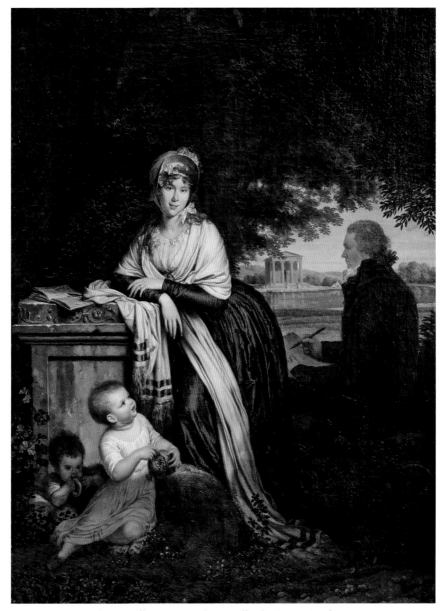

Fig. 8. Louis et Pauline Gauffier, *Portrait of the Gauffier family*, 1793, oil on canvas, 72,5 x 54,5 cm, Florence, galerie des Offices, dépôt au Palazzo Pitti, Galleria d'Arte Moderna, inv. 1890 :8404.

by both Louis Gauffier and his wife, Pauline. It depicts Pauline with her two children, Louis and Faustine, in the Borghese gardens. There Pauline is shown posing leaning on a pilaster while her husband, while engaged in drawing, is seen seated against the background of a lake and a classical *tempietto*. (Fig. 8) After his early attempt at such an intimate form of portraiture Gauffier continued to specialise in representations which underlined his ability to express both the values and joys of family life.

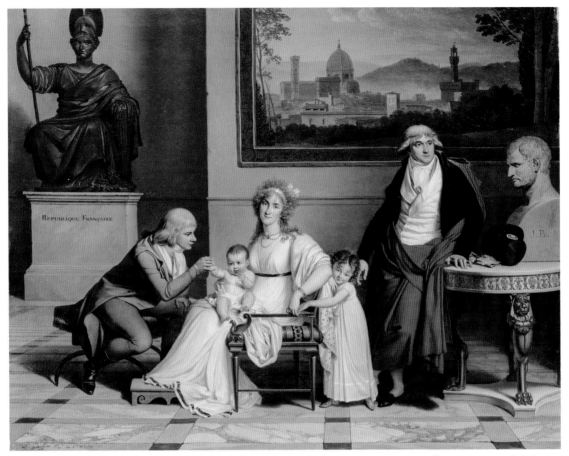

Fig. 9. Louis Gauffier, *Portrait of the Miot family*, 1796-1797, oil on canvas, 68,7 x 88 cm, Melbourne, National Gallery of Victoria, inv. 2010.513.

Notwithstanding that Gauffier had had prior opportunities to paint some of his international Grand Tour clients in the company of their children,[7] his first true conversation piece was only commissioned after the arrival of the French in Tuscany, when he painted the family of Ambassador François Miot (formerly at The Matthiesen Gallery London, from whom acquired by The National Gallery of Victoria, Melbourne). This painting was executed between 1796 and 1797 following the arrival of the Miot family in Florence in 1795 (Fig. 9). The painting shows the sitters in quite naturalistic poses while also including, however, both a bust of Brutus and a sculpture of Minerva, representing the French Republic. This is a pointed symbolic and political reference to Republicanism.

7. For example the *Portrait of Count Mauritz Gustaf Armfelt and his son Gustaf Magnus* (1793, oil on canvas, Helsinki, National Museum, inv. 26069 :128), the *Portrait of the princess Ekaterina Galitzine Menchikova and her son Alexandre* (oil on canvas, 68,5 x 87,8 cm, unknown location) or again the *Portrait of Lady Elizabeth Webster with her son Godfrey Webster* (1794, oil on canvas, 54,5 x 43 cm, Montpellier, musée Fabre, inv. 62.1.1). See Anna Ottani Cavina, Emilia Calbi, *op. cit.*, n° R 8 p. 207, n° R12 p. 211, n° R 13 p. 212-213 and Anna Ottani Cavina in Michel Hilaire, Pierre Stépanoff, *op. cit.*, n° 99 p. 308-311.

In contrast, the portrait of the Sainct-Même family (*Picking Oranges or La Cuiellette*), is only the second known example of a genre commission where the painter has used the subject of gathering oranges from the tree so as to enhance the joyful sense of a family gathering. The orange at this time was still a relatively exotic fruit which was symbolic of a visit to the South (see the Preface).[8] In this latter picture we can see Gauffier depicting a closely interrelated family full of affection and tenderness in its interaction between the figures. As was his custom, the artist placed the mother, who is the central pillar of the family, at the very centre of the composition. Surrounded by her numerous progeny it is she who is assuming the role of the family provider, gathering and distributing the fruit to the children while at the same time maintaining a pose which is both gracious and full of intimacy. She might almost be considered to be dancing on tiptoe, and thus in this role she is somewhat evocative of the role of a Virgin of the Misericord watching over her protégés. The inclusion of such delightful details as the watering can on the left side of the composition, almost records a sense of a daily and mundane existence, but Gauffier does not forget his formation as a history painter well-grounded in a knowledge of traditional and antique sculpture. He aligns all his figures parallel to the picture plane somewhat echoing the format of a bas-relief classical frieze. Both the upturned Corinthian capital and the Gorgon's head, decorating the Tuscan terracotta vase in which the orange tree is planted, accentuate a sense of the antique, again underlining the strength of Gauffier's attachment to the Neoclassical movement, even in his portraiture. The white crinoline dresses represent contemporary fashion, but even here the artist has attentively studied and represented a rhythm in the folds of the garments, worn by both the women and the children, so evoking a sense of the nobility of young Greek or Romans as represented in Classical sculpture. This very point was noted at the time by the duchesse d'Abrantès. The hesitation denoted in the figure of Rosalie, as well as in her profile, gesture, costume and her sinuous shawl, represent some of the finest passages in this composition. Here the artist also implies a fleeting reference to a young vestal virgin crowned with a wreath of flowers. Disregarding the question of fashion, this combination of a bygone taste linked to family values was also wholly appropriate to the promotion of Republican values in family life. The French Revolution had tended to laud the concept of Greek and Roman family life, which considering it both virtuous and patriotic, the very basic unit of construction for civic responsibility. Might there be a possible political allusion to the colours of the French tricolour in the juxtaposition of the chromatic values in this composition? Rosalie's blue shawl and Anne Joséphine's blue dress contrast with the white muslin of both Anne Henriette Elise and her daughter, Antoinette François' white garments. These in turn are set off against the red drapery framing the seated baby at the very centre of the composition. Quite possibly this is a reference to the consular status of the father and head of the Sainct-Même family. Such possibly discrete allusions combine

8. Compare this to Goethe's famous poem evoking Italy: *Kennst du das Land, wo die Zitronen blühn ?*.

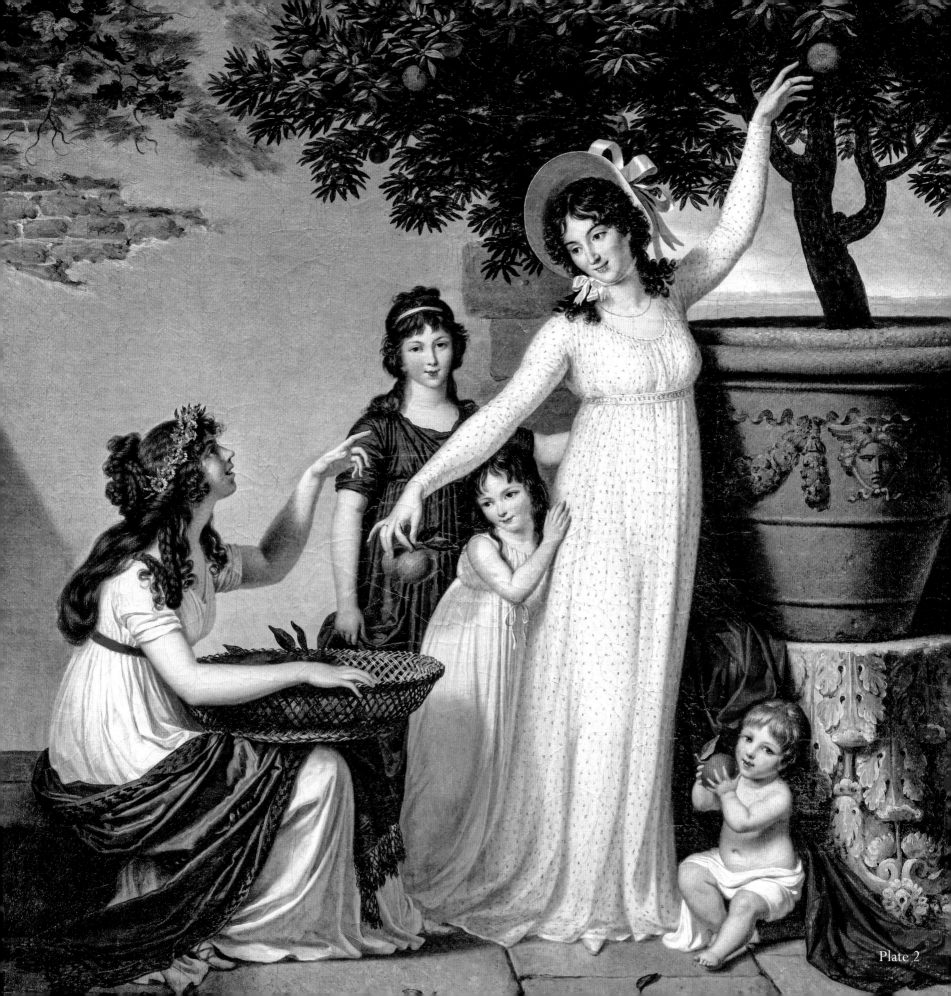

Plate 2

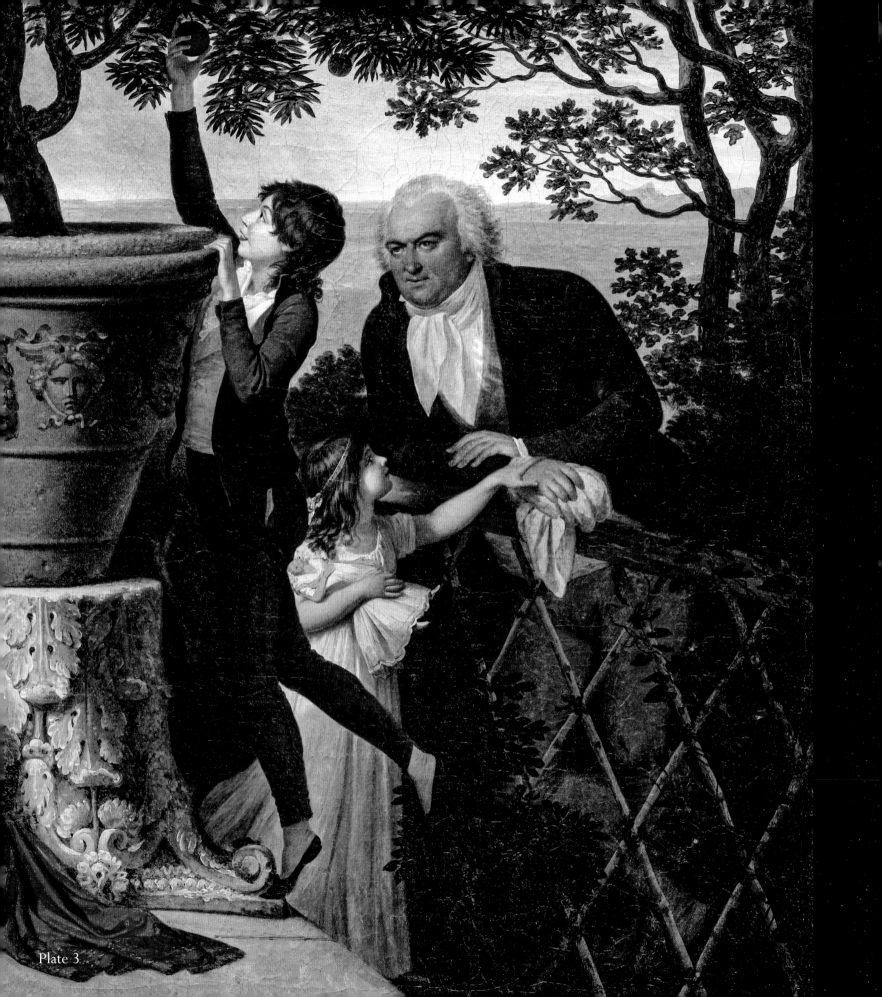

Plate 3

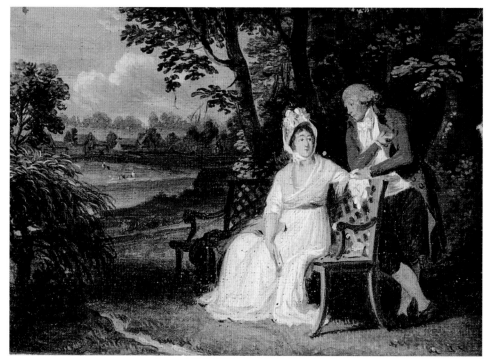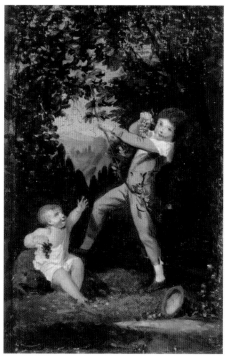

Fig. 10. Louis Gauffier, *Reduction of the portrait of an unidentified couple in a garden*, 11 x 15 cm, a detail from the eleven reduced size portraits, oil on canvas, 34,5 x 47 cm, Montpellier, musée Fabre, inv. 876.3.34.

Fig. 11. Louis Gauffier, *Reduction of the portrait of two children picking grapes*, oil on canvas, 14 x 9 cm, Versailles, musée national des châteaux de Versailles et de Trianon, inv. MV 4850.4.

successfully with Gauffier's carefully observed naturalistic details such as the orange tree, the vine fronds and the backdrop of the peeling intonaco of the brick wall which is accentuated by a raking shadow. To the right, the head of the family and his eldest son are set off against a distant luminous landscape.

This *Portrait of the Sainct-Même family* is a key and important rediscovery for any assessment of Gauffier's role as a painter of groups, families, or couples. There are several small *répliques* of this composition which the artist had painted, thus allowing us to guess as to the existence of other, yet to be discovered, paintings and to hope that these may still come to light. In a portrait of a couple who are engaged in discourse in a garden (Fig. 10) the character of the vegetation seems more Northern European rather than Italianate. In this very Anglicised composition Gauffier evokes certain paintings by Gainsborough to a surprising degree. In another painting a mischievous and greedy boy (Fig. 11) is gorging himself on grapes while his younger brother, still a baby, stretches out a hand expressing his wish to participate in this treat. Our portrait of the Sainct-Même family remains Gauffier's most ambitious multifigured attempt at representing a family engaged in mundane domestic activity.

From the very earliest days of his stay at the Académie de France in Rome and subsequently throughout his career, Gauffier never stopped studying nature and learning about landscape. Standing at his window, he had plenty of time to observe the reflections of light at differing times of day. The painter set up his easel in the open-air during excursions in the Roman countryside, to Tivoli or the Alban Hills. These often lasted for several weeks. In direct contact with nature, he trained an almost scientific eye, observing the shape of a leaf, or the surface of a piece of bark (Fig. 12). Although as the winner of the Prix de Rome his task had been to create great biblical, mythological, and historical subjects, right from his earliest paintings he was particularly attracted to landscape, the result of long studies. This practice undoubtedly brought Gauffier close to artists of different training and nationality, who were attracted to the beauties of nature rather than to the dramas of Antiquity. These included the Frenchmen Bidauld and Boguet, the German Hackert or the Swiss painter Sablet. Painting *en plein air* Gauffier's observations and detailed studies anticipate the studies of later 19th century artists. These studies were never intended to be sold or even exhibited. They constitute the artist's personal working repertoire or aide-memoire, a set of motifs at his disposal for composing more complex works in the studio or for incorporation into the background of his portraits. They culminate in the first accomplished landscape painted by Gauffier, a view of Florence, executed in 1795 following his move to the Tuscan capital two years earlier. Shortly thereafter he painted his landscape masterpieces, the four 1797 paintings of the Vallombrosa Abbey. The abbey, founded in 1038, lies at the heart of a forest of beech and conifers in the Apennines. It had become a well-known stopover on travel itineraries. Remodelled in 1637, the abbey had retained its monumental aspect, like a fortress in the heart of sovereign nature. Following a commission, whose origin is still unknown, the painter visited this site in August 1796, travelling the thirty kilometres from Florence. Gauffier created four 'portraits' of a real place and the preservation of all his preparatory studies produced during his stay there allows us to follow his creative process with remarkable precision (Figs. 13, 14, 15, 16).

Fig. 12. Louis Gauffier, *Study of two eucalyptus and umbrella pine tree trunks*, 1785-1792, oil on paper, 30 x 23 cm, Montpellier, Musee Fabre, Inv. 825.1.235.

Fig. 13. Louis Gauffier, *The Vicano Waterfall in Vallombrosa*, 1797, oil on canvas, 84 x 114.9 cm, San Francisco, Fine Arts Museums of San Francisco, Inv. 1996.119.2.

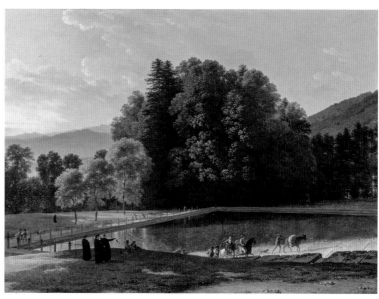

Fig. 14. Louis Gauffier, *Farewell to the monks of Vallombrosa*, 1797, oil on canvas, 82.5 x 114.3 cm, Philadelphia, The Philadelphia Museum of Art, Inv. W1975.1.2.

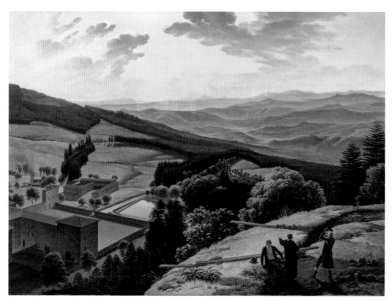

Fig. 15. Louis Gauffier, *The Vallombrosa Abbey and the Arno valley seen from the Paradisino*, 1797, oil on canvas, 82.5 x 114.3 cm, Philadelphia, The Philadelphia Museum of Art, Inv. W1975-1-1.

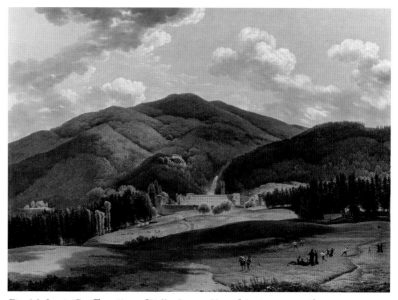

Fig. 16. Louis Gauffier, *View of Vallombrosa, abbey of the Apennines*, oil on canvas, 1797, 84 x 116 cm, Montpellier, Musee Fabre, Inv. 2008.1.1.

In contrast to the accepted tradition of historic landscape painting, where nature serves only as a backdrop for the narration of a mythological story, he instead focused on the beauty of the site, rather than the architecture of the building. The painter chose four viewpoints. Using various studies he made a drawing on a large sheet of paper onto which, like a surveyor, he analysed each plan of the site, each tree species, each item of foliage. An oil sketch, created in just a few minutes, captures a vivid memory of both light and colour. Back in Florence, and with the help of his studies, Gauffier then created the four large paintings. But once in the studio the views became the setting for an evolving daylong story, the visit of two elegant travellers guided by the monks from the abbey. This classical narrative, based on a unity of time, place and subject, is enhanced by the liberties taken with the studies themselves. In order to achieve an idealised sense of beauty, the painter simplified his compositions so as to find the essential character of the site. These views are enhanced by the dazzling use of light, which subtly suggests the passing hours, until the final farewell before dusk. On the eve of romanticism, Gauffier has used landscape so as to reflect a state of mind, that of a memorable visit tinged with nostalgia. Such sensitivity would consequently permeate the arts of the 19th century.

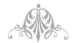

The continuing chest infection that had worn down the health of both Louis and Pauline Gauffier in Florence became more serious in 1801. He barely had time to finish his last portrait which depicted General Dumas, an officer born in the West Indies and father of the novelist Alexandre Dumas. Pauline died in July, followed in October by her grief-stricken husband, leaving two orphaned children, Louis and Faustine. The painters Desmarais and Mérimée, as well as the sculptor Chaudet, organised the sale in Paris of those paintings that remained in the studio, with the proceeds going to the two children, while François-Xavier Fabre collected the paintings and drawings of his friend. In 1825 he offered them to the museum of Montpellier, his native city, thus guaranteeing that Gauffier's memory would remain preserved. Gauffier was only 39 years old.

PIERRE STÉPANOFF

GAUFFIER AND HIS PORTRAITURE

When historical events forced the artist to flee Rome and seek refuge in Florence, a celebration of pure landscape became his primary artistic interest. His training at the Académie in Rome had led to a youthful exploration of the city and its surrounding countryside. Instead, portraiture, however, was a new departure for the artist and only dates from the time of his arrival in the grand-ducal city of Florence where he is recorded in 1793. The artist is not known to have executed any portraits while in Rome. In contrast once in Florence post 1793, we know that he executed a number of commissions since seven portraits all bear that date. Just as in Victor Hugo's unforgettable novel *Quatrevingt-treize*, 1793 is the year which marks a radical change in Gauffier's output. In the many portraits he executed in Florence for an international clientele, all depicted on a reduced scale, Gauffier follows an anti-heroic path, where the character portrayed and the common man intersect. François Lagrenée, the director of the French *Académie*, wrote that after 1785 Gauffier was *'peu accoutumé à peindre le grand'*.[1] His representations have a tendency to diminish the formal and rather to express on occasion a feeling of intimacy. In a portrait of a *Gentleman with a Dog* it is possible to see the emotional bond between the aristocrat and his canine friend. Gauffier's portrait representations relate to a theme addressed by Robert Rosenblum, in his exhibition *Portrait Publique, Portrait Prive*. At a magical point of development for portraiture he states that artists reacted *'directement ou de façon subliminale aux bouleversements en cours, marqués par des événements traumatisants … Ce fut également une époque durant laquelle peintres et scuplteurs étudièrent l'imaginaire et les émotions jusqu'à des nouvelles profondeurs, scrutant leur propre image comme s'ils écrivaient leur journal intime ou réinventant la personnalité de leurs modèles (…)'*.[2]

1. Letter from Louis Lagrenée the Elder to the Count of Angiviller, Rome, 19 October 1785 (*Correspondence of the directors of the Académie de France in Rome with the Superintendents of Buildings,* Paris, Charavay, 1906, t. XV, p.49).

2. Robert Rosenblum, *Portrait Publique, Portrait Privé*, Paris, London and New York 2006-2007, pp. 13-14.

FLORENCE

On May 3, 1793, the Florentine Academy of Fine Arts admitted Louis Gauffier to the ranks of the 'academic professors'.[3] As a result of this and also the fact that he had previously been at the Académie de France in Rome, Gauffier immediately acquired a prestigious clientele. The artist found many doors opening to him and this was the particular case with British tourists. The city's location at a crossroad of the Grand Tour itinerary resulted in a cosmopolitan environment. Furthermore, the city, politically, was a center of anti-Bonapartism, a tendency reinforced by the Salon of the Countess of Albany.[4] The French government had caused many artists to flee Rome and this accentuated Florence's importance as a cultural center, resulting in the renaissance of such institutions as the Accademia della Crusca and the Florentine Academy. The 19th century reforms of Grand Duke Leopold II in Florence had been anticipated by a transition to modernity already before the end of the previous century. This was the same sense of modernity that Ugo Foscolo noted when commenting in his diaries about those international travellers whom he recognized as differing from their predecessors.[5] Gauffier had only painted six sacred, historical or mythological works between 1795 and 1798, instead adopting the more lucrative role of a portrait painter in order to serve this selfsame international clientele. How then did Gauffier access this new *upper-class* clientele and why did he so immediately appear attractive to a social stratum to whom religious and classical sentiments were so alien?

THE ENGLISH CLIENTS

The most numerous sitters posing for Gauffier were those British travellers described in the twentieth-century memoirs of Sir Harold Acton as being 'from Signa to Vallombrosa, as taking root among the vineyards, becoming part of the Tuscan landscape...'.[6] The veritable focal cultural 'hotspot' in the

3. ASABAFi, Role of the Academicians Acts 1785-1807, c. 51; Cfr. Borroni Salvadori 1986, p. 88 note 761.
4. Cfr. Tognarini, *Tuscany in the revolutionary age*, 1985
5. Ugo Foscolo, *Epistolario 1822-1824*, ed. 1958, XI, tomo II, pp. 229-298.
6. Harold Acton, 'Memoir of an environment', in *The Idea of Florence, Themes And Interpretations In art Foreign Nineteenth century*, Acts of the colloquium, Florence, 17-19 December 1986, Florence, Centro DI, 1989, Maurizio Bossi, Lucia Tonini (Italy) (dir.), p. 21.

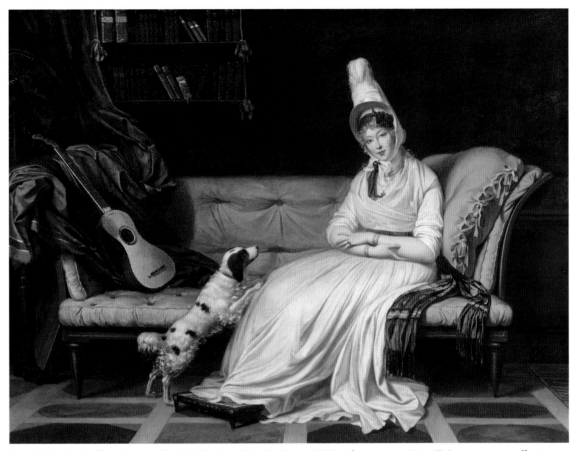

Fig. 17. Louis Gauffier, *Portrait of Lady Holland with her dog Pierrot*, 1795, oil on canvas, 51 x 67,5 cm, private collection, New York.

city of Florence was the Salon of the Countess of Albany, much frequented by both artists and *illuminati*. Louise de Stolberg, Countess of Albany, was the widow of Charles Edward Stuart, Pretender to the British throne. He had fled Paris together with Vittorio Alfieri, whose portrait was later painted by François Xavier Fabre, another *habitué* of the Salon. Both Alfieri and the Pretender had fled France leaving behind a beautiful mansion on rue de Provence, designed by the great architect Claude-Nicolas Ledoux. Since November 1792 the countess had chosen to live in Palazzo Gianfigliazzi in Florence on the Lungarno, near the Santa Trinità bridge.[7] Stendhal, the great 19th Century romantic author, mercilessly chronicled this love story: *'Le sombre Alfieri, le poëte aristocrate par excellence, qui se croyait parce qu'il abhorrait tout ce qui était plus haut placé que lui dans l'échelle sociale, enleva sa femme au dernier des Stuarts ; il vivait avec elle à Florence, et devait terriblement l'ennuyer. M.*

7. Carlo Pellegrini, *The Comtesse d'Albany and the Sabatto del Lugarno,* Naples, Edizione scientifiche italiane, 1951.

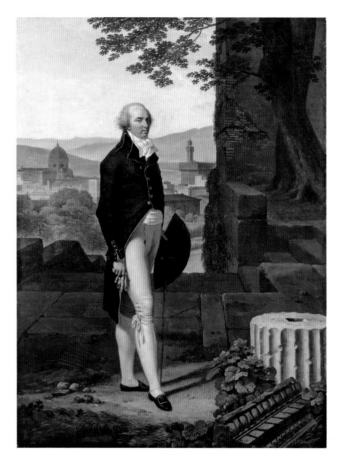

Fabre, petit peintre admis dans la maison, finit, dit-on, par faire mourir Alfieri de jalousie.[8]

In Florence Gauffier's rapid preeminence as an artist might lead one to suspect that he had arrived in the city with a well filled Filofax of addresses. Indeed in Rome he had been able to approach both Lady Ann Flaxman, the Irish painter Hugh Douglas Hamilton, active in the city from 1779 to 1791, and Cardinal de Bernis. The latter had endowed him with important introductions and credentials at the time of his migration to Florence. Handwritten notes, made by the late Sir Brinsley Ford and taken from the original, but almost illegible, manuscript of lady Flaxman in the British Museum,[9] record nine occasions between March the 14th 1791 and January 30, 1793, when Louis Gauffier, together with his wife, Pauline Chatillon, attended a variety of 'drinks, tea, large parties' which had been organized by her Ladyship in Rome, and which were frequented by influential artists and foreigners. Lady Holland's Diary reveals further information.[10] Elizabeth Vassal Webster, later Baroness Holland, (Fig. 17) had arrived in Florence in October 1792. She was then just twenty-one years old. At fifteen she had

Fig. 18. Louis Gauffier, *Portrait of Sir Godfrey Vassal Webster*, oil on canvas, 69 x 59 cm, 1794, Battle Abbey, East Sussex, English Heritage.

been married to Sir Godfrey Webster (Fig. 18) and it was to be a difficult and also tumultuous relationship, destined to end upon her meeting in February 1794 with Henry Richard Vassal Fox, third Baron Holland, who became her new lover in Naples. Just prior to this event her diary reports that in May 1793, on her

8. 'Somber Alfieri the aristocratic poet par excellence who thought himself superior to all others because he could not stand the idea of anyone placed higher than he in the social scale, he seduced the wife of the last of the Stuarts; they lived together in Florence only to bore her to distraction. Mr Fabre, a minor painter who had been given access to the household finished, it is said by succeeding in making Alfieri die of jealousy'. Stendhal *Memoirs of a tourist,* 1838; quoted in Pellicer, Hilaire 2008, p. 18.

9. *Mrs Flaxman's Diary*, London, British Museum, Add. Mss. 39792A.

10. Elizabeth Holland, *The Journal of Elizabeth Lady Holland (1791-1811),* 2 vol., edited by the Earl of Ilchester, London, Longmans, Green and co., 1908, p.38.

return from Naples to Florence, Lady Holland broke the journey in Rome meeting on several occasions with Cardinal François-Joachim de Pierre de Bernis. Despite having been removed from his position as the French ambassador in Rome, on account of his political views contrasting with the directives of the Revolution, the cardinal still held an influential position in the political and cultural life of the city. Gauffier benefited from a privileged relationship since his wife's father was a chamberlain in the Cardinal's household. Thus, one might imagine that it may have been de Bernis himself who provided the introduction to the Holland household for Gauffier. Cardinal de Bernis had exercised a long and distinguished career as a diplomat, and thus it is likely that it was he who also provided the introduction to Lord Hervey, Plenipotentiary Minister of His Britannic Majesty at the Grand Duchy of Tuscany (1787-1794). Reading between the lines, it is not unreasonable to deduce that the motivation for an exasperated attack by the painter Jean-Baptiste Wicar against Gauffier may be explained by the fact that Wicar was a fervent Jacobine. Wicar denounced Gauffier's 'infamous conduct' demanding that he be denoted as a 'traitor' in the lists of emigrants from Rome. He further described Gauffier as being 'the nominated painter of the infamous Lord Hervey Ambassador of England and also a *protégé* of the so-called Prince Augustus, the most bitter enemy of France'. He went on to describe Gauffier as having a relationship 'with the cardinal of aristocracy, Bernis'.[11] Naturally this attack, resulting from competition in the same marketplace, was made all the more bitter because of privileges enjoyed by Gauffier, while under the protection of Lord Hervey.

A healthy sense of pragmatism had propelled Gauffier away from subject painting and instead into portraiture. Such contacts as permitted the painter to prosper were largely antirevolutionary and pro-British and the artist had formed the basis for his relationship before leaving Rome.[12] Such an intellectual and political posture was one that Gauffier also shared both with François-Xavier Fabre and Jean-

11. *Minutes of the general commune of painting, sculpture, architecture and engraving arts and the popular and republican Societé des arts, with an introduction and notes by Henry Lapauze*, Paris, imprimerie nationale, J.E. Bulloz editeur, 1903, p.202-203; Louis Hautecoeur, Louis David, Paris, La Table ronde, 1954, p.139.

12. It is worth recording a few lines of the French diplomat François Cacault, stationed in Florence,: 'Gauffier ... and his wife ... are weak souls, for whom the sound of the revolution frightens, and who crawl before the aristocracy to have work. But their morals are pure and respectable. ... their probity and gentleness win affection and are worthy of praise.' (*Correspondance des directeurs*, XVI, p. 393).

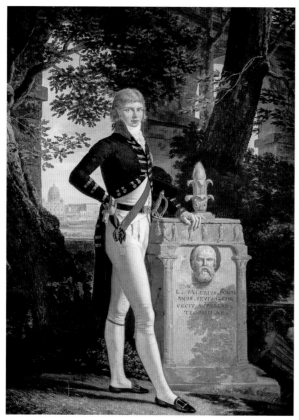

Fig. 19. Louis Gauffier, *Portrait of Prince Augustus Frederick, future Duke of Sussex*, oil on canvas, 69 x 50.5 cm, 1793, Karlsruhe, Staatliche Kunsthalle.

Baptiste Frédéric Desmarais, but other Florentine refugees such as Nicolas-Didier Boguet, Jacques-Henri and Jean-François Sablet and Bénigne Gagneraux appear to have had more Republican learnings.

While transiting from Rome to Florence, a crucial moment in Gauffier's portrait development is marked by one of his most beautiful portraits, that of the young Prince Augustus Frederick, future Duke of Sussex, in blue dress jacket (Fig. 19). Signed and dated *L. Gauffier Flor.* ^ce *1793*, but set against a backdrop of Rome, this painting stands at a watershed between two different creative periods of the painter. Far from what would become the icy elegance of Fabre, and rather closer to the melancholy of Sablet, as refined and precious as an enchanting Florentine Boilly, Gauffier introduces a very successful new formula.[13] Unlike the Davidian portraits of the Age of the Revolution, Gauffier's figures are no longer viewed against a compact backdrop. Instead they are inserted into a natural and intimate framework that emphasizes both interiors or evocative Italian landscapes. Compared to the life-size portraits of Pompeo Batoni, Gauffier prefers a reduced scale (a third of the life-size format with minimal variations in the canvas size in a ratio 60 or 65 x 50 cm) and a more domestic setting, in parallel with the portraits of Jacques Sablet and, in some respects, of Hugh Douglas Hamilton, an Irish painter active in Rome from 1779 to 1791. Even when, as in his *Duke of Sussex*, one may still sense Batoni's more rigid neoclassical heritage, the artist instead captures a transitory reality of a fragile and seductive young man, denoting a polite air of culture inherited from the masters of English portraiture. Likewise, the languid presence of lady Bessborough (Fig. 20), who abandons herself to the embrace of nature barefoot, in a classical guise, reflects the subtly erotic attitude

13. Pierre Rosesmountain in *Poussin,Watteau, Chardin, David. French paintings in German collections,* Paris, Grand Palais, 20 April – 1 August 2005, Paris, meeting of national museums, 2005, Pierre Rosenberg (dir.), p. 344.

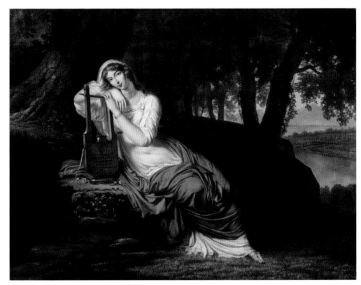

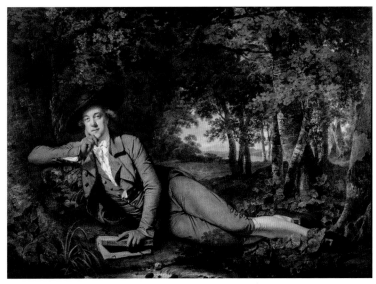

Fig. 20. Louis Gauffier, *Portrait of Lady Bessborough*, oil on canvas, 49,5 x 63,5 cm, c. 1793, Melbury House, Dorset, Dorchester collection, the Hon. Mrs. Charlotte Townshend.

Fig. 21. Joseph Wright of Derby, *Portrait of Brooke Boothby*, oil on canvas, 148,6 × 207,6 cm, 1781, London, Tate Britain, inv. N04132.

with which Jean-Marc Nattier in France had updated the portraits of court ladies surprised in the woods in the guise of Flora or Diana. Furthermore, it embodies a rediscovered reconciliation with a natural world that, in the wake of Rousseau, the English had expressed with lyrical understatement (Fig. 21), and that Gauffier now proposes once again in an unknown lady with blue eyes painted against a background of Tivoli.[14] Sometimes, as in the challenging portrait which he made in four variations for Baron Gustaf Mauritz Armfelt (Fig. 22), Gauffier restores to the portrait its potential for conveying a political message. The signage is in fact very explicit with the depiction of the busts of Gustav III of Sweden and Julius Caesar and in the lettering engraved in Roman capital characters, which attest to

Fig. 22. Louis Gauffier, *Portrait of Gustaf Mauritz Armfelt in meditation in front of the busts of Gustav III and Julius Caesar*, oil on canvas, 50 x 65.5 cm,1793, Stockholm, Nationalmuseum.

the loyalty of the Swedish baron to the murdered sovereign and his anti-revolutionary sentiments. Portraits of a gentleman, one in the National Portrait Gallery, London, and one once in the Koudacheff Collection, both

14. *Portrait of a woman as a Muse against the backdrop of Tivoli,* 1794. Hartford, CT, Wadsworth Atheneum.

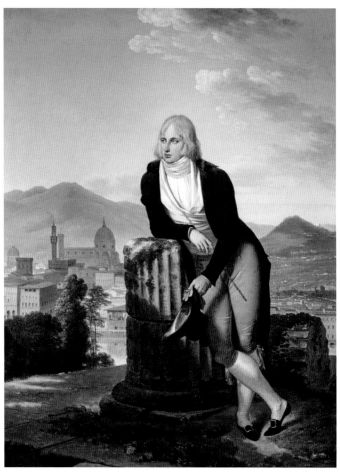

Fig. 23. Louis Gauffier, *Portrait of a young man in Florence*, oil on canvas, 66.7 x 50.2 cm, 1796. London, National Portrait Gallery.

dated 1796 (Fig. 23), express both a romantic sense of abandonment and a sense of self-confidence which are light years away from the static and heroic portraits of contemporary Napoleonic France. Almost invariably signed and dated, Gauffier's portraits are mostly of single figures in sophisticated British informality (Fig. 24, 25).

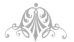

It is probable that, during his Roman years, Gauffier had direct contact with British culture through the person of Hugh Douglas Hamilton (1736-1808). In turn this resulted in true friendships with Antonio Canova, John Flaxman and his wife Ann, who could all attest to Hamilton's network of international acquaintances ('acquainted with most of the English nobility').[15] Around 1790 and having been in Rome for almost ten years, Hamilton realized a series of portraits that, in their layout, their cut, and their relationship between landscape and figure prepared the way to a surprising degree for certain Florentine masterpieces by Gauffier.[16] Although, if one compares the actual paintings, the differences at once emerge – differences of scale first and foremost where Hamilton maintains traditional dimensions while Gauffier introduces a 'Hellenistic' reduction in his figures. Also, Hamilton's technique was pastel on paper whereas Gauffier used oil on canvas. Differences are evidenced by a comparison of the nuanced and *sfumato* backgrounds in Hamilton's works compared to the optical scrutiny of nature, the city of Florence, and of the passages of light and shadow within the clouds in the skies as represented in

15. *Flaxman Papers*, British Library Add. Ms. 39780, f. 45, letter by John Flaxman ai parents, Rome 30 August 1788.

16. His most important client was Friedrick Augustus Hervey, Lord Bristol and Bishop of Derry. On Hugh Douglas Hamilton see the catalogue of the exhibition curated by Anne Hobbs, cf. Dublin 2008 - 2009.

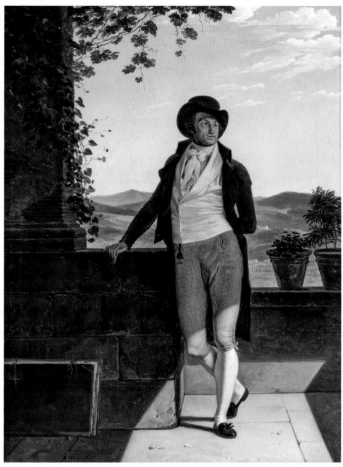

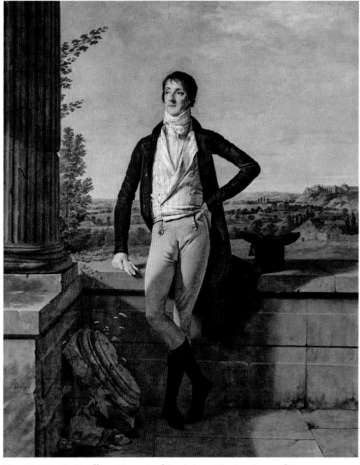

Fig. 24. Louis Gauffier, *Portrait of the painter Guillaume Joseph Coclers Van Wyck*, oil on canvas, 67.5 x 51.5 cm, 1797, Montpellier, Musée Fabre.

Fig. 25. Martin Drölling, *Portrait of Barthelemy Charles, Count of Dreux-Nacre*, oil on canvas, 94 x 75 cm, 1797, private collection.

Gauffier's paintings. In Hamilton's *Portrait of Lord Bristol*, the view of the city of Rome, partly framed by the terrace on the Pincio, is represented as a backdrop bathed in a diffused light but which is entirely secondary to the prominence given to the figure (Fig. 26).[17]

On several occasions Gauffier framed some of his portraits in such a way that one might feel it might almost be possible to touch the cityscape. In his portrait masterpiece of Thomas Penrose, Gauffier expresses his mastery of the supreme moment of integration between the figure portrayed and the countryside, that is between man and nature (Fig. 27). Thomas Penrose was a friend of Lord and Lady Webster. He stands against a romantic

17. 'In quegli anni, il personaggio tende a esprimere nuove emozioni e un'immagine interiorizzata della bellezza, tributo a quella "poetica degli affetti che, con David e Canova, aveva toccato punti altissimi di pathos e di vera commozione"'. Anna Ottani Cavina, 2022, Briganti 2002, p. 208

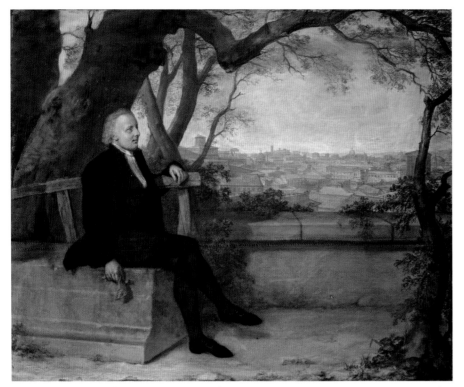

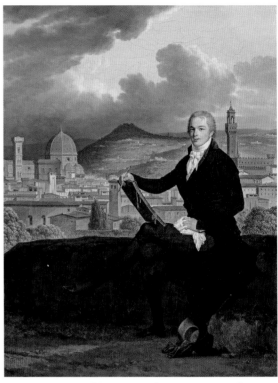

Fig. 26. Hugh Douglas Hamilton, *Portrait of Frederick Augustus Hervey, Lord Bristol, on the hill of the Pincio, in Rome*, 1790, pastel on paper, 97.8 x 118.1 cm, Ickworth, National Trust.

Fig. 27. Louis Gauffier, *Portrait of Thomas Penrose*, oil on canvas, 69 x 53 cm, 1798, Minneapolis, Institute of Art.

backdrop of sky, clouds and wind, which served to contrast with the precisely depicted image of Florence with its classic, iconic architecture. Seated on a terrace in the Boboli gardens, behind Palazzo Pitti in the Oltrarno, Penrose is captured posing as the archetypal English Grand Tourist. This image of Penrose draws the eye and steals the scene. Florence is represented against the green hills of Fiesole. The sitter stands flanked by the mass of Santa Maria del Fiore, Giotto's *campanile*, the extremity of Orsanmichele and, on the opposite side, Palazzo Vecchio with its tower - an extraordinary cross-section of Florence towards the end of the eighteenth century. This is a representation of a poetic melding of the relationship between traveller and his surroundings.

Among Gauffier's international clientele, which included Lords Holland and Wycombe, as well as Princess Katarina Nikolaievna Galitzine Mensijkova, it is also necessary to mention the name of François-Xavier Fabre, a close friend, with whom Gauffier had undertaken many an excursion into the Tuscan hinterland (Figs. 28, 29). Fabre was four years Gauffier's junior. The differences in their relative treatments of portraiture may be seen by comparing two 1795 portraits of Lord Wycombe, the liberal and Whig friend of Lord Holland. In Fabre's portrait the sitter is shown holding a book in his hands in the typical pose of an aristocratic *dilettante* (Fig. 29). Gauffier, on the other hand, is less superficial. He sets his sitter against a windblown sky and the Livorno port's lighthouse,

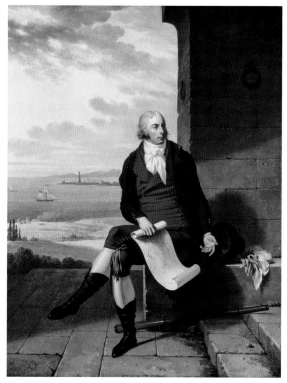

Fig. 28. Louis Gauffier, *Portrait of John Henry Petty, Earl of Wycombe, second Marquess of Lansdowne*, 1795, oil on canvas, 73.7 x 48.4 cm, Bowood Estate, Calne, Wiltshire, collection of the 9th Marquis of Lansdowne.

Fig. 29. François-Xavier Fabre, *Portrait of John Henry Petty, Earl of Wycombe, second Marquess of Lansdowne*, 1795, oil on canvas, 106 x 86 cm, Dublino, National Gallery of Ireland.

thereby creating an image inferring an indefatigable traveller, one who is also curious about his surroundings. This is underlined by the accoutrements of a map of Italy and, lying on the ground beside him, a telescope (Fig. 28). Lady Holland wrote in her *journal* that he was 'a very eccentric person'. The two artists differed in their development. Gauffier, from 1793 produced a continuous stream of innovative portraits. Fabre, instead, feeling himself more of a history painter for whom *'le portrait n'était pas sa vocation première'* was much slower in taking up portraiture.[18] He was, fundamentally, an intellectual, perhaps lacking in imagination and therefore disinclined to risk innovations of composition and style. In Fabre's art the analytic and descriptive style of his master, David, is always evident and he has a preference for half-figure portraits. Philippe Bordes, considered Fabre's style of portraiture limiting, despite the variations in scale, expression and setting. For Bordes, Fabre's output was more eclectic than experimental for 'he was receptive to most of the portrait modes of the time'.[19]

18. L. Pellicer, M. Hilarie, *François-Xavier Fabre, peintre et collectionneur*, in « L'Objet d'Art », n. 2, 2000; see also Ph. Bordes, François-Xavier Fabre, *'Peintre d'Histoire'*, I and II, in « The Burlington Magazine » CXVII, 1975 and L. Pellicer, *Il gagnait à être connu*, in « François-Xavier Fabre », exhibition 's catalogue Spoleto, Rome 1988.

19. Ph. Bordes, *French Art and Artists*, Burlington Magazine, 2008, p. 354.

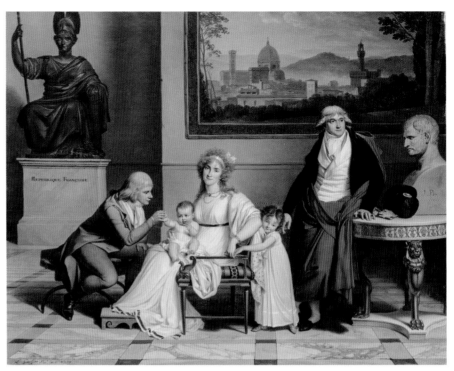

Fig. 30. François-Xavier Fabre, *Study for a standing portrait of Lord Holland,* pencil on paper, 41.5 x 31 cm, c. 1796, Montpellier, Musée Fabre.

Fig. 31. Louis Gauffier, *Portrait of the Miot family*, oil on canvas, 68.7 x 88 cm, c. 1796, Melbourne, National Gallery of Victoria, formerly London, Matthiesen Gallery.

Such an analysis, although quite accurate when considering Fabre's finished works, does not make allowance for Fabre's more complex working process. In a preparatory drawing for the *Portrait of Lord Holland* (Fig. 30), his handling is sensitive and not at all rigid, in fact quite intimate in feeling. It is indeed less formal than the full-length by Gauffier. However, in the full scale finished work Fabre steps back to a more formal style. In his portraiture, after Gauffier's death in 1801, Fabre borrows from his friend by setting his figures in landscape, yet Fabre's landscapes are idealized, classical and enameled rather than being actual observations. In Fabre's celebrated portraits of Alfieri and Canova (1812) his subjects are forever frozen as icons of their time, realized with an acute sense of realism as if in a '*sublime miroir qui dit la vérité*'.[20]

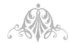

20. This is this is the title of a contribution by Laure Pellicer in the special issue of *L'Objet d'Art* (2000, p. 20), dedicated to Fabre painter and collector.

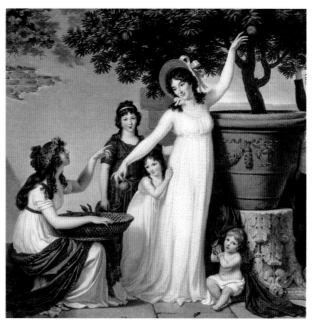

Fig. 32. Louis Gauffier, *A Family Portrait of the Sanct-Mêmes. La Cueillette des Oranges*, oil on canvas, 69 x 99 cm, 1797-1798, London, Matthiesen Gallery.

Fig. 33. Louis Gauffier, *A Family Portrait of the Sanct-Mêmes. La Cueillette des Oranges*, detail, London, Matthiesen Gallery.

FAMILY PORTRAITS

For some time after Gauffier's arrival in Florence he executed only single figure portraits with the exception of one or two family portraits based on the model of British conversation pieces which are distinct from group portraits. These family portraits such as *The Miot Family* (Fig. 31) and *La Cueillette des Oranges* (Plate 1, p. 25 & Fig. 32) illustrate a renewed interest in both domesticity and the maternal role of the housewife, particularly in her relationship to her offspring. This reflected an increased interest in the education of children which had been promoted by the writing of Rousseau. In *La Cueillette des Oranges* the construction of the composition is a veritable juxtaposition of gestures and attitudes which serve to accentuate the intimacy of the scene being enacted within a society whose stability had been threatened by the unfolding historical events of the period (Fig. 32, 33). This was a society which may be said to have preferred a relatively prosaic representation of its actual social status, rather than a more poetic and formal celebration (Fig. 34, 35).[21] Such representations are echoed throughout French art of the period, albeit with slight variations and can be seen in works from Greuze to Vigée Le Brun and from Vincent to Boilly.[22] Yet for Gauffier these remain isolated

21. R. Rosenblurn, *Portrait Publique, Portrait Privé*, Paris, London and New York 2006-2007, p. 324.

22. On the theme, in France, of the new main role attributed to childhood, Cfr.. Louveciennes 2003

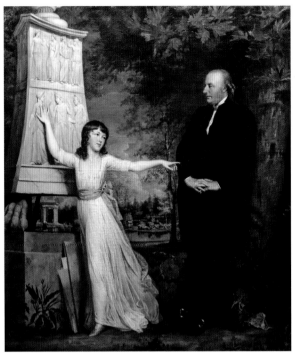

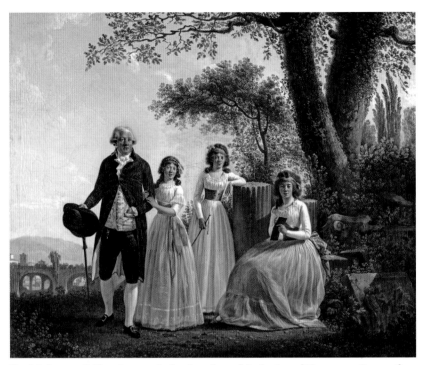

Fig. 34. Hugh Douglas Hamilton, *Portrait of Frederick August Hervey, fourth Lord Bristol, with his granddaughter Lady Caroline Crichton in the gardens of the Villa Borghese, in Rome*, oil on canvas, 224.4 x 199.5 cm, c. 1790, Dublin, National Gallery of Ireland.

Fig. 35. Jacques Sablet, *Portrait of a family in front of the Basilica of Maxentius in Rome*, oil on canvas, 60 x 72 cm, 1791, Losanna, Musée Cantonal des Beaux-Arts.

episodes which probably reflected the specific requests of his patrons rather than representing experimental compositional ideas developed by the artist himself.

Jacques Sablet, a Swiss painter who grew up between Paris and Rome and who was nicknamed *'le peintre du soleil'*, painted the most lyrical visions of family life. Wandering lost in the Farnese gardens on the Palatine hill, a father and his three daughters, who are dressed in white muslin, are lit by the raw and enchanted light of a Roman Summer's day. Sablet portrays them with surprisingly modern candor and naturalness, *'après un siècle de portraits mis en scène dans des fracas d'étoffes … des mines finaudes et satisfaites, après tant de complaisance envers la comédie sociale'* (Fig. 35).[23]

23. J. - P. Cuzin, *Jacques Sablet, or the painting of the passing of time*, in 'Les frères Sablet (1775-1815)', catalogue of the exhibition curated by Anne Van de Sandt, Nantes-Lausanne-Rome 1985 …

It is notable how few portraits Gauffier seems to have executed in 1797. His creative efforts were probably absorbed by his work executing the four great landscapes of Vallombrosa their related drawings and preparatory sketches. At around this time Napoleon's Italian campaign threw Italian society into disarray, equally interrupting the flow of Grand Tour tourists, and the passage of a new bourgeois clientele. It's at this precise moment in 1797 that Gauffier paints his ravishing portrait of the painter Philippe Guillaume Joseph Cocklers (Fig. 24, p. 61). The sitter stands before a low wall, surmounted by two terracotta vases, against the hilly background which is bathed in light just as in his Vallombrosa's landscapes. That same year a portrait of Martin Drölling is constructed in a similar way also against the verdant wooded countryside and a low stone wall, but in this painting the vases are lacking and are instead substituted by a large, wide brimmed top hat (Fig. 25, p. 61). At this time Drölling (1752-1817) enjoyed fame, but later lapsed into obscurity until his reputation was revived in the 19th century by Louis Aragon. Of Alsatian origin he had grown up in Paris, at first inspired by the purity of form of Chardin's works, and totally extraneous to Davidian influence.

NEW CLIENTS, THE FRENCH ARMY IN ITALY

After 1796 the French army under the command of Napoleon Bonaparte took over the Grand Duchy of Tuscany, occupying Livorno, which until then had been garrisoned by the British and paying a visit to Florence itself. The morning of the 1st of July 1796 Bonaparte met with Ferdinand III of Habsburg-Lorraine in the full presence of the Tuscan court. [24] For two years the Grand Duchy had succeeded in maintaining neutrality while revolutionary France fought a war with imperial Austria. However, with war raging on several fronts Florence was occupied from March to June 1799 and then again in October 1800. Ferdinand who had taken refuge in Vienna on the 27th of March 1799 was unable to return, even after the Treaty of Lunéville (9th of February 1801), which had assigned the newly named 'Kingdom of Etruria' to Louis I of Bourbon.

24. It was probably on that occasion that Gauffier could see Napoleon and execute 'the small portrait of Bonaparte oil painting' that lord Holland had commissioned from him before leaving Florence. The canvas was shipped to London but was lost during the journey (Russell 1994, p. 443, note 30).

These political changes, perforce, obliged Gauffier to adopt a new clientele which was primarily French and also drawn from military circles. He adopted his style to suit those ambitious generals, field marshals and Napoleonic officers, who were desirous of a memento of their Italian campaign. He depicted them in evocative poses or more official portraits, in uniforms, set against both nature and an extensive background.[25] Jacques Sablet also emulated this style of portraiture, combining a skillful combination of brightly illuminated spaces with a certain naturalistic candor (Fig. 36). Both Gauffier and Sablet depict their sitters within a decidedly reduced format, choreographed against these wide expansive backdrops. Both artists pay great attention to such military minutiae as the soldiers' scabbards, silk sashes, cockades, boots, tricolored plumes and a large array of medals, gilt buttons and gold piping (Fig. 37a, 37b, 38, 39).

The repetitive nature of Gauffier's output between 1799 and 1801 took place within a domestic studio overshadowed by the tuberculosis which was to cut short the lives of Pauline on the 27th of July 1801 (*'sa femme qu'il aimait éperdûment'*),[26] followed by Louis less than three months later. Both parents were only too aware that their young children Louis and Faustine, aged ten and nine respectively, would be left as orphans. It is sufficient to read the will that Gauffier dictated on the 26th of August 1801[27] in a desperate attempt to guarantee the future of the children, to comprehend his distress.

GAUFFIER, HOW HE WORKED

A few days after the artist's death on October the 20th 1801, his friend, the painter Frédéric Desmarais, asked the Opificio delle Pietre Dure in Florence for permission to use the ground floor room in a building in San Nicolò 'which had been enjoyed by the late Gauffier for the last two years'.[28] In that very room, Gauffier had started work on a large painting which he left uncompleted: *'Il a laissé l'ébauche d'un*

25. Cf. Bordes, 1970-1973, pp. 73-74.

26. Cf. *Obituary* in Moniteur, 1802

27. See the unpublished will found by Emilia Calvi and published in facsimile in the volume Anna Ottani Cavina, Emilia Calbi, *Louis Gauffier, un pittore Francese in Italia,* Silvana Editoriale 2022.

28. C. Giamblanco, P. Marchi, *Archivio di Stato di Firenze, Imperiale e Real Corte*, Ministry for Cultural and Environmental Heritage, Florence, 1997.

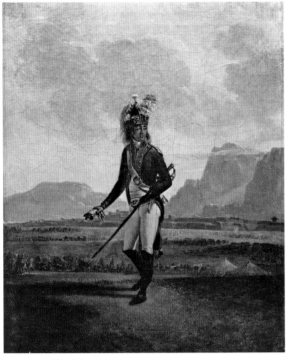

Fig. 36.

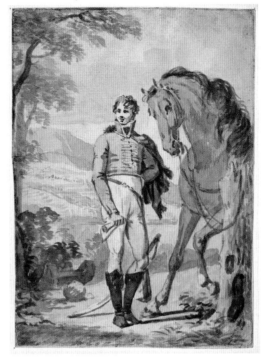

Fig. 37a.

Fig. 37b.

Fig. 36. Jacques Sablet, *Portrait of an officer of dragoons*, circa 1795, oil on canvas, 59 x 46 cm, private collection, Saint-Gall.

Fig. 37a. Louis Gauffier, *Hussar officer with his horse*, Poitiers, Musée Sainte-Croix.

Fig. 37b. Jacques-Louis David, *A Gentleman leaning on his horse*, black crayon on paper, 18.7 x 12.6 cm, Paris, Musée du Louvre, Carnet I, n. 1266.

Fig. 38. Louis Gauffier, *Portrait of Etienne Michaux, commissioner of wars, and director of division*, oil on canvas, 64.5 x 46 cm, 1801, current location unknown.

Fig. 39. Louis Gauffier, *Portrait of Joseph St. Cricq, ordinary commissioner of wars of the first class*, oil on canvas, 67 x 51 cm, 1801 Paris, Musée Marmottan.

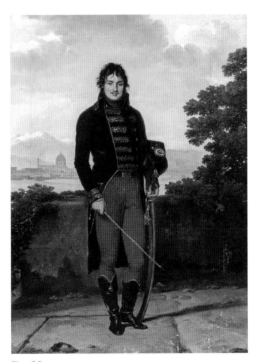

Fig. 38.

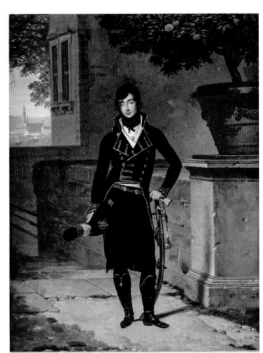

Fig. 39.

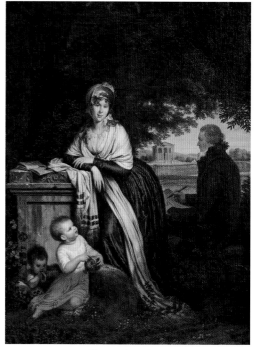 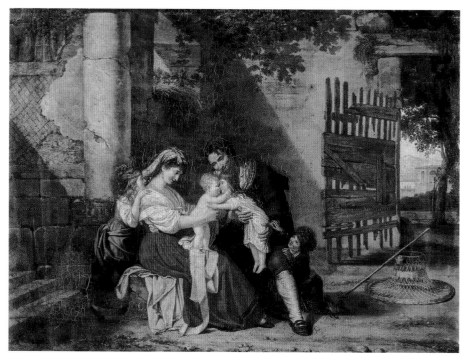

Fig. 40. Louis Gauffier and Pauline Chatillon, *Portrait of the Gauffier family*, oil on canvas, 72.5 x 54.5 cm, 1793, Florence, Palazzo Pitti, Galleria d'Arte Moderna.

Fig. 41. Pauline Chatillon, *Family reunion in an Italian farm*, oil on canvas, 49.8 x 68.6 cm, 1792, current location unknown.

très grand tableau qui lui avait été demandé, et qui a beaucoup contribué à accélérer la perte totale de ses forces'.[29] The room which Desmarais was seeking to occupy appears to have been a temporary space and not the studio in which Gauffier had been accustomed to work alongside his wife Pauline. Their actual studio, where the couple painted side by side since Pauline had an independent career which had been much appreciated by her clients, may have been located inside a house in Via Larga. This, however, does not exclude the fact that she may have collaborated in some of her husband's paintings (Fig. 40) and more particularly in those replicas that clients traditionally loved to order to give as gifts to members in their entourage.[30] Pauline's small canvases still await study and a catalogue raisonné but their does not seem to be a significant difference in her style between her Roman years and her Florentine period. Their subject matter concentrates on those feelings of domesticity and happiness, where mothers and children are shown in a close and loving relationship, in courtyards, on the

29. Cf. *Obituary,* cit.

30. For example the case of *Baron Gustaf Mauritz Armfelt in meditation in front of the statues of Gustav III and Julius Cesar* which four versions are known. Cfr. Supinen 1997.

doorstep, among strolling passersby or enjoying the delights of their toys, snacks or kittens (Fig. 41). In yet another painting an old fortune teller predicts the future, and a woman reacts furiously to a predatory feline which has invaded the kitchen space.

By elevating family values to be the role model for a form of social harmony, something that should be based on a sense of natural, domestic coexistence, the artist is portraying a vision of humanity which verges on the Arcadian. In effect, after the political ideology promoted by the French Revolution was succeeded by the stormy history of the Napoleonic period, Gauffier promotes a calmer vision of the world based on private virtues. This was later to find its real expression in the Europe of the *Biedermeier* period.

Looking at Pauline's paintings it is impossible not to note that they reflect a sense of reality, 'the most perfect image of happiness' which, indeed, was noted by Hackert, Desmarais and Castellan... *'Les talens, la douceur et l'amabilité de Mme Gauffier faisoient le charme de sa famille et du petit cercle d'amis qui se réunissoit chez elle à Florence. [...] elle se borna à retracer sur la toile des scènes familières [...]. Les plaisirs, les devoirs de l'amour conjugal, les craintes, les espérances de la maternité; telles sont les scènes naïves qu'elle traçoit avec autant d'esprit que de sentiment, et qu'elle rendoit piquantes par l'emploi des costumes si variés des villageois italiens.'*[31] Indeed, Jacques Sablet, working in Rome, had, since 1789, also emphasized both the themes of childhood and the sacred nature of family life. In this he was a counterpart to Pauline's own activity projecting the subject matter of genre painting to a much higher level which, until then, had been solely reserved for history painting.[32]

Although he was responsible for creating a new, more intimate and modern style of imagery in his portraiture, Gauffier, like other leading artists such as Batoni, made use of theatrical sets within his studio against which he places his clients. This is a methdology that was later to be emulated by photographers in the 19th century. As part of his repertoire for these theatrical backdrops he might include Vesuvius and the Bay of Naples, plastered walls with cracks, earthenware vases, marble stelae, fragments of

31. A.L. Castellan, *Lettres sur l'Italie...*, Paris 1819, Vol. III.

32. See the picture *First steps of childhood*, Forlì, Pinacoteca Civica, 149 x 202 cm; this painting is exceptionally large for a work by Sablet.

columns or capitals, the casts of Classical statues, or indeed leafy branches from oak trees to simulate a view *en plein air*. On the other hand, when the subject was to be placed in an interior such as in *Mrs Elizabeth Billington at the fortepiano* of 1795, one realizes that the backdrop is shared with other portraits such as in that considered to be of the wife of Marshal Masséna (1799), or those of Ferdinando Nerli or Johan Claes Lagersväld, both also dated from 1799 where the background may be reversed.

Pierre Stépanoff identified a preparatory drawing which helps us to reconstruct Gauffier's working process. Here, the composition is traced on a squared sheet of paper ready for transposition onto a canvas. Gauffier drew an interior which is that appearing in a portrait traditionally considered to portray Marshal Masséna. Both the setting and the décor correspond but the sitter who is depicted in the drawing is a very young man and is not the portrait image represented in the oil painting. Whether this was for a different project, or client, or was just a first generic draft proposal for the new client is not important but it shows Gauffier's working process. By matching the preparatory studies to the paintings one can appreciate the sustained rhythm of Gauffier's output. From this one may imagine a queue of prospective military personae passing through the Florentine studio of the painter, one by one, selecting a stock type of imagery which could be rapidly executed. The artist in turn making quick sketches with pen and bistre ink, or pencil, to note the physiognomy and details to insert into his repertoire of imagery.

SMALL PORTRAITS

That Gauffier had a stock repertoire is given credence by the fact that there survive a series of '*petits portraits*' (Fig. 42) which are the size of a playing card. These are preserved in the museums of Versailles Montpellier and Barnard Castle.[33] These small paintings primarily relate to known finished portraits by the artist, but some may relate to lost works. Mounted in series on canvas they should probably be considered as *ricordi* or *aides- memoire* rather than as preparatory sketches. Thus, they served to preserve a memory of a finished painting, even though the dimensions are so much smaller, and where a sitter may be depicted standing against a well-defined backdrop (Fig. 43). In a somewhat abbreviated and more sketchy style, these small-

33. Whereas those in Versailles and Montppellier are certainly autograph, those in the Bowes Museum are copies by another hand.

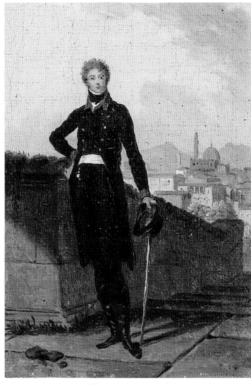

Fig. 42. Louis Gauffier, *Eleven Miniature Portraits*, oil on canvas, 34.5 x 47 cm, Montpellier, Musée Fabre.

Fig. 43. Louis Gauffier, *Young English man with the background of Florence, Eleven Miniature Portraits*, oil on canvas, 34.5 x 47 cm Montpellier, Musée Fabre.

format reductions retain the characteristics of larger, completed portraits. In effect they constitute an archive of settings and poses with which the artist could seduce a perspective client into confirming a commission, or, alternatively fulfill a request for a replica. In the case of the *Portrait of Baron Gustaf Mauritz Armfelt* (Fig. 22) four versions were executed. Gauffier's portraits differ from those executed after the 1780s by Louis-Léopold Boilly, whose commercial success resulted in a huge number of almost miniature portraits executed *'avec la vitesse de l'éclair'*. In effect, Boilly was known to complete each one within a sitting of two hours, in which time he was able to paint a perfectly recognizable resemblance. These small works were half-length images framed in a three-quarter format against a neutral background, which might often be dark grey or beige, measuring about 20 x 15 cm, and all available at a very affordable price.[34]

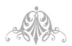

34. E. Breton, P. Zuber, *Boilly, Le peintre de la société parisienne de Louis XVI à Louis-Philippe*, Paris 2019, vol. I pp. 200, 201, 202.

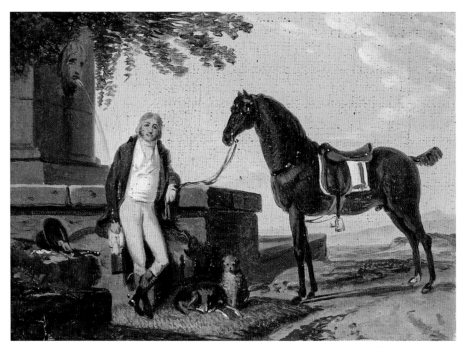

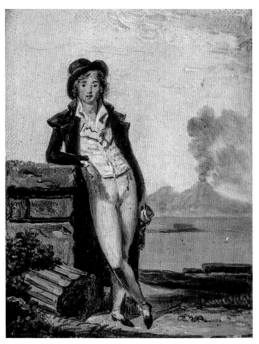

Fig. 44. Louis Gauffier, *Gentleman with his horse*, Montpellier, Musée Fabre.

Fig. 45. Louis Gauffier, *Young Traveler in front of the Vesuvius*, oil on canvas, 9.5 x 7 cm, current location unknown.

Despite pressures caused by the mounting demand for his work, exacerbated by failing health and a pressing need of money for his family, Gauffier's still managed to create some enchanting small-scale portraits in his final years such as *the Gentleman with his horse* and the *Young Traveler against the backdrop of Vesuvius*, formerly in the Parisian collection of the great dancer and choreographer Serge Lifar (Fig. 44, 45). As an observer of a rapidly changing society, Gauffier managed to reflect such diverse sensations as a spirit of adventure, of nonchalance, or of ambition tempered by a veil of melancholy which suffused the spirit of a new, young Napoleonic generation. This generation was experiencing for the first time the intoxication of liberty. These were novel experiences for they had been suppressed for some time by Jacobin ideology. Gauffier now introduced then for the first time into the imagery of his young patrons who were often anonymous.

ANNA OTTANI CAVINA

74

APPENDIX I

FRAME

French Louis XVI scotia frame in oak with three orders of ornament moulded in Plaster of Paris: *piastres* on top outer edge, threaded beading or 'shot' on the frieze and *rais-de-coeur* or lambs tongues at the sight edge; original matt and burnished water gilding, c.1760-1800.

This frame was extended by 2 mm in the height and 11 mm in the width to completely maximise the sight size of the painting. All the joinery to the frame has been secured.

The composition ornament checked and secured as required, losses restored. All major gesso losses have been restored, original surface cleaned, and all restorations have been gilded to blend into remaining original surface.

An oak lining has been added to the rear of the frame to accommodate the canvas and provide a secure environment. Rebates lined with brown paper tape and conservation grade felt, painting fitted into frame with brass plates.

APPENDIX II

CONDITION REPORT

SUPPORT

The original canvas has a very open weave. It has two preparatory layers; the first being an orange/red ground colour which was applied to fill the interstices between the canvas threads. The second preparatory layer is a luminous, creamy-white, oil-based priming which is visible on the original turnover edges. It has been applied thickly, in order to disguise much of the canvas texture and to offer a smooth reflective surface for the artist to paint onto. As is typical in paintings of this period prepared in this manner, a network of long age cracks developed over time, which projected forward in front of the picture plane. The existing lining did not hold the cracks adequately in plane. As part of the recent structural treatment the prominence of these cracks has been reduced (See Conservation Treatment below). This treatment successfully holds the age cracks in plane, but other age cracks are still visible to some extent to give an authentic surface texture to the overall composition.

The top centimetre of the composition had been stretched onto the turnover edge during the previous lining. This was re-incorporated into the picture plane during lining and the lined painting has been stretched onto a new bespoke stretcher.

PAINT LAYERS

The paint is in very good condition having suffered almost no abrasion in past restorations and very little accidental damage. The transparent, dark green glazes applied by the artist as a base layer for the orange trees are beautifully preserved and the finely applied leaves, particularly where they are semi-translucent and pass over the sky show no evidence of abrasion. There were two pinpoint losses on the basket-holding girl's proper right forearm and in her neck which had been retouched in the past and a small loss in the mother's dress below the waist caused by pressure from the reverse. In the main part of the composition there are a small number of pinpoint losses at the confluence of age cracks. There have been some localised peripheral paint losses perhaps caused by the frame rebate and the folding over of the top edge. These losses have been treated. (See below for Conservation Treatment) The inscription at lower left is perfectly intact and the paint layer retains all its detail, texture, and luminosity.

CONSERVATION TREATMENT

CLEANING

Old layers of discoloured varnish were reduced and the two discoloured retouchings in the seated girl's forearm were readily removed.

STRUCTURAL WORK

This was carried out by Timothy Watson. The old lining was removed, and the painting was given an overall flattening treatment in order to reduce the prominence of the age cracks. The painting was then double lined onto linen canvas using glue paste adhesive. The use of two layers of linen canvas was instrumental in holding the long age cracks in plane. A decision was taken to return the folded over top edge back onto the picture plane and the lined canvas was stretched onto a new bespoke stretcher.

RETOUCHING

Minor losses were filled using chalk and gelatine and then a brush varnish was applied prior to retouching using a dammar varnish. The retouchings were carried out using Gamblin conservation colours. Retouching work concentrated on the peripheral losses along with tiny dots of retouching in the main part of the composition. Certain cracks running through some of the flesh tones were suppressed with dots of retouching where they were considered to disturb the reading of the modelling. A final spray of dammar varnish was applied to unify surface gloss.

CAROL WILLOUGHBY
04.01.2022

BIBLIOGRAPHY

H. ACTON, 'Memoir of a environment', in *The Idea of Florence, Themes And Interpretations In art Foreign Nineteenth century*, Acts of the colloquium, Florence, 17-19 December 1986, Florence, Centro DI, 1989, Maurizio Bossi, Lucia Tonini (Italy) (dir.), p.21.

B. ALEXANDER, *Brigands et Galants*, 2002, Editions 10/18, p. 208.

E. BRETON, P. ZUBER, *Boilly, Le peintre de la société parisienne de Louis XVI à Louis-Philippe*, Paris 2019, vol. I pp. 200, 201, 202.

PH. BORDES, *François-Xavier Fabre, 'Peintre d'Histoire ', I*, in « The Burlington Magazine » CXVII, 1975, pp. 90-98.

PH. BORDES, *François-Xavier Fabre, 'Peintre d'Histoire ', II*, in « The Burlington Magazine » CXVII, 1975, pp. 155-163.

F. BOYER, *Le Monde des Arts en Italie et la France de la Révolution et l'Empire*, Turin, Società Editrice Internazionale 1969.

A. L. CASTELLAN, *Lettres sur l'Italie …*, Paris 1819, 3 vol.

J. P. CUZIN, *Jacques Sablet, or the painting of the passing of time*, "Les frères Sablet (1775-1815)", catalogue of the exhibition curated by Anne Van de Sandt, Nantes-Lausanne-Rome 1985.

J. DAVID, *Le Peintre Louis David 1748-1825, souvenirs et documents inédits*, Paris 1880, t. I, p. 45

J. FLAXMAN, *Flaxman Papers*, British Library Add. Ms. 39780, f. 45, letter by John Flaxman to his parents, Rome 30 August 1788.

M. FLAXMAN, *Mrs Flaxman's Diary*, London, British Museum, Add. Mss. 39792A.

U. FOSCOLO, *Epistolario 1822-1824*, ed. 1958, XI, Vol. II, pp. 229-298.

GAZETTE DES BEAUX-ARTS, *Le peintre Louis Gauffier*, tome 13, 1926, p. 286.

C. GESSNER, *Correspondance des directeurs de l'Académie de France à Rome …*Paris 1887-1912, vol. XV, p. 171 ; *Recueil des lettres de la famille de Salomon Gessner*, Parigi 1801-1802, vol. II , pp. 102-103.

M. HILAIRE, P. STEPANOFF, *Le Voyage en Italie de Louis Gauffier*, catalogue d'exposition Montpellier, musée Fabre, 7 May – 4 September 2022, Gand, Snoeck, 2022.

A. HODGE, *Hugh Douglas Hamilton (1740-1808) : a Life in Pictures*, ehibition's catalogue Dublin, National Gallery of Ireland, 22 November 2008 – 15 February 2009, Dublin, National Gallery of Ireland, 2008.

E. HOLLAND, *The Journal of Elizabeth Lady Holland (1791-1811), 2 vol.*, edited by the Earl of Ilchester, London, Longmans, Green and co., 1908, p.38.

L. JUNOT, *Mémoires de Madame la duchesse d'Abrantès, ou Souvenirs historiques sur Napoléon : la Révolution, le Directoire, le Consulat, l'Empire et la Restauration*, Paris, Ladvocat, 1831, t. II, p. 98-99.

C. KYSER, *L'Enfant chéri, au Siècle des Lumière*, exhibition's catalogue Louveciennes, musée Promenade Marly-le-Roi, 10 June– 12 October 2003, Paris, L'inventaire, 2003.

LA BEQUILLE DE VOLTAIRE AU SALON, Paris 1791, p. 35, n. 695.

L. LAGREENE, Letter from Louis Lagreene to the Count of Angiviller, Rome, 19 October 1785 (Correspondence of the directors of the Académie de France in Rome with the Superintendents of Buildings, Paris, Charavay, 1906, t. XV, p.49).

C.P. LANDON, *Annales de l'Art Français* Vol. II 1802, p. 209.

H. LAPAUZE, *Minutes the general commune of painting, sculpture, architecture and engraving arts and the popular and republican societe des arts, with an introduction and notes by Henry Lapauze,* Paris, national printing press, J.E. Bulloz editeur, 1903, p.202-203.

J. LAPAUZE, *Société populaire et républicaine des arts*, 1923, pp. 201-202.

P. MARMOTTAN, Le *peintre Louis Gauffier*, Gazette des Beaux-arts, 1926, p. 285.

A. MONTAIGLON, J. GUIFFREY, *Correspondance des Directeurs …*, vol. XV, p. 49.

A. OTTANI CAVINA, *I Paesaggi della Ragione*, Torino 1994.

A. OTTANI CAVINA, E. CALBI, *Louis Gauffier, un pittore francese in Italia*, Silvana Editoriale (Fondazione Federico Zeri), 2022, catalogue number R25 pp.224-225, figure 78, page 112.

C. PELLEGRINI, *The Comtesse d'Albany and the Sabatto del Lugarno,* Naples, Edizione scientifiche italiane, 1951.

L. PELLICER, *L'Art Object*, 2000, p. 20.

L. PELLICER, *Il gagnait à être connu*, in « François-Xavier Fabre », exhibition 's catalogue Spoleto, Rome 1988, pp. 13-21.

L. PELLICER, M. HILAIRE, *François-Xavier Fabre, peintre et collectionneur*, in « L'Objet d'Art », n. 2, 2000.

S. ROSENBLURN, *Les faits contre la fiction*, in « Portraits publics, Portraits privées 1770-1830 », catalogue of the exhibition Paris, London, New York 2006-2007.

P. ROSESMOUNTAIN, *Poussin, Watteau, Chardin, David. French paintings in German collections,* Paris, Grand Palais, 20 April – 1 August 2005, Paris, meeting of national museums, 2005, Pierre Rosenberg (dir.), p. 344.

A. ROUILLAC, « Réunion de la famille Sainct-Même sous le Directoire », *Rouillac*, 2020, <https://www.rouillac.com/fr/news-2458-reunion_famille_sainct_meme_sous_directoire>.

B. SALVADORI, 'Role of the Academicians Acts 1785-1807', c.51, 1986, p. 88 note 761.

I. TOGNARINI, *La Toscana nell'età Rivoluzionaria e napoleonica,* Edizioni Scientifiche Italiane, 1985.

A. VAN DE SANDT, *Les Frères Sablet (1775-1815),* Edizioni Carte Segrete, Roma 1985.

EXHIBITION CATALOGUES

THE MATTHIESEN GALLERY, LONDON 1978

Those marked ¶ Matthiesen Gallery in association with Stair Sainty Matthiesen
Those marked ‡ edited and published with Stair Sainty Matthiesen

1979 *British Printmakers 1812–1840.*
52 pages with 431 items, many illustrated (edited by James Ingram – out of print).

1980 *Symbolist and Art Nouveau Prints – Autumn Catalogue.*
80 pages fully illustrated (edited by James Ingram – out of print).

1981 *Important Italian Baroque Paintings, 1600–1700.*
An exhibition in aid of The Frescoes by Guarino at Solofra damaged by earthquake.
Foreword by Alvar González-Palacios.
100 pages, 22 colour plates, 34 black and white illustrations.
£20 or $30 + p. & p. (scarce).

1981 *Fine Prints and Drawings: England, America and Europe.*
60 pages with 173 items, many illustrated (edited by James Ingram – out of print).

1983 *Early Italian Paintings and Works of Art, 1300–1480.*
An exhibition in aid of The Friends of the Fitzwilliam Museum.
Introductory essay by Dr Dillian Gordon on 'Painting Techniques in Italy, 1270–1450'.
127 pages, 22 colour plates, 34 black and white illustrations.
£12 or $18 + p. & p.

1984 *From Borso to Cesare d'Este, 1450–1628: The School of Ferrara.*
An exhibition in aid of *The Courtauld Institute Trust Appeal Fund.*
Ten introductory essays on Ferrara and aspects of Ferrarese art by Cecil Gould,
Lanfranco Caretti, Claudio Gallico, Vincenzo Fontana, Thomas Tuohy,
Emmanuele Mattaliano, Giorgio Bassani, Giuliano Briganti, Alastair Smith,
with charts and Concordat of Ferrarese paintings in British public collections.
200 pages, 50 colour plates, 84 black and white illustrations.
£15 or $23 + p. & p.

¶ 1984 *The Macchiaioli.*
122 pages, fully illustrated (out of print).

¶ 1984 *Three Friends of the Impressionists: Boldini, De Nittis, Zandomeneghi.*
53 pages, fully illustrated (out of print).

1985 *Around 1610: The Onset of the Baroque.*
 An exhibition on behalf of Famine Relief in Ethiopia by *The Relief Society of Tigray*.
 Introduction by Sir Ellis Waterhouse.
 120 pages, 33 colour plates, 22 black and white illustrations (scarce).
 £12 or $18 + p. & p.

‡ 1985 *The First Painters of the King: French Royal Taste from Louis XIV to the Revolution.*
 Catalogue by Colin Bailey, including three comprehensive essays by Philip Conisbee,
 Jean-Luc Bordeaux and Thomas Gaehtgens. Introduction by Guy Stair Sainty.
 Inventory of paintings by the 'First Painters in Public Collections in the USA'.
 144 pages, 21 colour plates, 243 black and white illustrations (out of print).

1986 *Baroque III: 1620–1700.*
 An exhibition in memory of Sir Ellis Waterhouse and on behalf of *The National
 Art Collections Fund*.
 Introduction by Sir Peter Wakefield. Essays by Francis Haskell, Cecil Gould,
 Francis Russell, Charles Mc Corquodale and Craig Felton.
 152 pages, 15 colour plates, 30 black and white illustrations.
 £15 or $23 + p. & p.

‡ 1986 *An Aspect of Collecting Taste.*
 Introduction by Guy Stair Sainty.
 68 pages, 24 colour plates, 7 black and white illustrations (out of print).

1987 *Paintings from Emilia, 1500–1700.*
 An exhibition held in New York at the Newhouse Galleries Inc.
 Foreword by Professor Sydney J. Freedberg. Introduction by Emmanuele Mattaliano.
 150 pages, 33 colour plates, 63 black and white illustrations.
 £15 or $23 + p. & p.

1987 *The Settecento: Italian Rococo and Early Neoclassical Paintings, 1700–1800.*
 An exhibition held on behalf of Aids Crisis Trust (UK) and *The American Foundation
 for Aids Research* (USA).
 Introduction by Charles McCorquordale. Essays by Francis Russell, Edgar Peters
 and Catherine Whistler.
 200 pages, 31 colour plates, 88 black and white illustrations.
 £15 or $23 + p. & p.

‡ 1987 *François Boucher and his Circle and Influence.*
 Introduction by Regina Shoolman Slatkin.
 136 pages, 18 colour plates, 80 black and white illustrations (out of print).

1989 *A Selection of French Paintings 1700–1840 Offered for Sale.*
An exhibition on behalf of *Médecins Sans Frontières.*
154 pages, 42 colour plates, 77 black and white illustrations.
£10 or $15 + p. & p.

¶ 1991 *Louis-Léopold Boilly's 'L'Entreé du Jardin Turc'.*
'Spectacle and Display in Boilly's "L'Entreé du Jardin Turc"'. Essay by Susan
L. Siegfried. 36 pages, 25 plates.
£10 or $15 + p. & p.

¶ 1991 *Eighty Years of French Painting from Louis XVI to the Second Republic 1775–1855.*
70 pages, 20 colour plates.
£12 or $17 + p. & p.

1991 *Pre-Raphaelite Sculpture. Nature and Imagination in British Sculpture 1 1848–1914.*
An exhibition organized by Joanna Barnes in association with *The Henry Moore
Foundation.* Hardback book to accompany the exhibition with 174 pages fully illustrated.
(available from the Henry Moore Foundation).

¶ 1993 *Fifty Paintings 1535–1825.*
To celebrate ten years of collaboration between The Matthiesen Gallery, London,
and Stair Sainty Matthiesen, New York.
216 pages, 50 colour plates, numerous black and white text illustrations.
£20 or $32 + p. & p.

¶ 1996 *Paintings 1600–1912.*
144 pages, 26 colour plates.
£12 or $20 + p. & p.

¶ 1996 *Romance and Chivalry: History and Literature reflected
in Early Nineteenth Century French Painting.*
Introduction (40 pages) by Guy Stair Sainty, twelve essays, catalogue,
appendix of salons 801–1824 and bibliography.
Hardback book, 300 pages, fully illustrated with 90 colour plates and 100 black
and white illustrations.
£50 or $80 + p. & p. (scarce).

1996 *Gold Backs 1250–1480.*
An exhibition held on behalf of *The Arthritis and Rheumatism Council.*
Foreword and four essays. Limited edition hardback catalogue of the exhibition
held in London and New York.
154 pages, fully illustrated with 37 colour plates and 54 black and white text illustrations.
£25 or $35 + p. & p. (scarce).

1997 *An Eye on Nature: Spanish Still Life Painting from Sanchez Cotan to Goya.*
 Foreword by Patrick Matthiesen. Catalogue entries by Dr William B. Jordan.
 Hard and softback catalogue of the exhibition held in New York.
 153 pages, fully illustrated with 23 colour plates and 65 black and white text illustrations.
 £30 or $40 + p. & p. (scarce).

1999 *Collectanea 1700–1800.*
 Hardback catalogue of the exhibition held in London and New York.
 220 pages, fully illustrated with 46 colour plates.
 £30 or $40 + p. & p.

¶ 1999 *An Eye on Nature II: The Gallic Prospect.*
 French Landscape Painting 1785–1900.
 Foreword by Patrick Matthiesen and Guy Stair Sainty. Hardback catalogue of the
 exhibition held in New York.
 195 pages, fully illustrated with 37 full colour plates and 65 black and white illustrations
 (many full page).
 £30 or $40 + p. & p.

2000 *Marzio Tamer: Recent Paintings.*
 Exhibition held on behalf of The World Wildlife Fund.
 Softback catalogue, 64 pages, 61 illustrations.
 £10 or $15 + p. & p.

¶ 2001 *European Paintings – From 1600–1917.*
 Baroque, Rococo, Romanticism, Realism, Futurism.
 Spring softback catalogue, 110 pages, 29 colour plates, 26 black and white illustrations.
 £15 or $20 + p. & p.

2001 *2001: An Art Odyssey 1500–1720.*
 Preface by Errico di Lorenzo and Patrick Matthiesen. 'El Bosque de Los Nino'
 by Patrick Matthiesen. Foreword, reminiscences and detailed inventory records
 of the Costa seventeenth-century archives by Patrick Matthiesen.
 Hardbound millennium catalogue with special binding, 360 pages, 58 colour plates,
 184 black and white illustrations.
 £35 or $45 + p. & p.

2002 *Andrea Del Sarto Rediscovered.*
 Essay by Beverly Louise Brown.
 Hardback catalogue, 60 pages, 9 colour plates, 18 black and white illustrations.
 Limited edition (out of print).

2002 *Gaspar Van Wittel and Il Porto di Ripetta.*
Essay by Laura Laureati.
Hardback catalogue, 52 pages, 2 colour plates, 23 black and white illustrations.
Limited edition.
£15 or $20 + p. & p.

2003 *Chardin's 'Têtes d'Études au Pastel'.*
Essay by Philip Conisbee.
Hardback catalogue, 33 pages, 2 colour plates, 12 black and white illustrations.
Limited edition.
£15 or $20 + p. & p.

2004 *Bertin's Ideal Landscapes.*
Essay by Chiara Stefani.
Hardback catalogue, 46 pages, 2 colour plates, 27 black and white illustrations.
Limited edition.
£15 or $20 + p. & p.

2004 *Polidoro da Caravaggio: Polidoro and La Lignamine's Messina Lamentation.*
Text by P. L. Leone De Castris.
Hardback catalogue, 62 pages, 11 colour plates, 15 black and white illustrations.
Limited edition.
£15 or $20 + p. & p.

2004 *Virtuous Virgins, Classical Heroines, Romantic Passion and the Art of Suicide.*
Text by Beverly L. Brown.
Hardback catalogue, 60 pages, 2 colour plates, 21 black and white illustrations.
Limited edition.
£15 or $20 + p. & p.

2007 *Manet, Berthe Morisot.*
Text by Charles Stuckey
Hardback catalogue, 32 pages, 11 colour plates. Limited edition. (out of print)

2007 *Jacobello Del Fiore: His Oeuvre and a Sumptuous Crucifixion.*
Text by Daniele Benati.
Hardback catalogue, 80 pages, 12 colour plates, 15 black and white illustrations.
Limited edition.
£15 or $20 + p. & p.

2008 *Jacques Blanchard: Myth and Allegory.*
 Text by Christopher Wright and Andrea Gates.
 Hardback catalogue, 5 colour plates, 6 black and white illustrations. Limited edition.
 £15 or $20 + p. & p.

2009 *A Florentine Four Seasons.*
 Text by Andrea Gates.
 Hardback catalogue, 96 pages, 11 colour plates, 21 black and white illustrations.
 Limited edition.
 £15 or $20 + p. & p.

2009 *Théodore Rousseau. A Magnificent Obsession: La Ferme dans les Landes.*
 Text by Simon Kelly and Andrea Gates.
 Softback catalogue, 52 pages, 3 colour plates, 16 black and white illustrations.
 Limited edition.
 £15or $20 + p. & p.

2009 *The Mystery of Faith: An Eye on Spanish Sculpture 1550-1750.*
 Various texts.
 Hardback silk blocked and bound. 300 pages.112 colour plates, 153 black and white
 illustrations.
 £60 or $75 + p. & p.

2010 *Révolution • République • Empire • Restauration.*
 Hardback catalogue, 84 pages, 11 colour plates, 39 black and white illustrations.
 £15 or $20 + p. & p.

2011 *James Ward: A Lioness with a Heron.*
 Text by Andrea Gates.
 Hardback catalogue, 48 pages, 3 colour plates, 14 black and white illustrations.
 £15 or $20 + p. & p.

2012 *Liberation & Deliverance - Luca Giordano's Liberation of St. Peter.*
 Texts by Helen Langdon and Giuseppe Scavizzi.
 Hardback catalogue, 60 pages, 7 colour plates, 21 colour and black and white illustrations.
 £15 or $20 + p. & p.

2012 *Joseph Wright of Derby: Virgil's Tomb & The Grand Tour*
 Texts by Jenny Uglow and Bart Thurber.
 Hardback catalogue, 76 pages, 5 colour plates and 74 black and white illustrations.
 £15 or $20 + p. & p. (scarce)

2013 *A Winning End-game: Francis Cotes, William Earle Welby and His Wife Penelope*
Text by Jenny Uglow.
Hardback catalogue, 48 pages, 6 colour plates and 17 black and white illustrations.
£15 or $20 + p. & p.

2013 *Vision & Ecstasy: Giovanni Benedetto Castiglione's St. Francis.*
Texts by Helen Langdon and Jonathan Bober.
Hardback catalogue, 84 pages, 20 colour plates and 47 black and white illustrations.
£15 or $20 + p. & p.

2014 *Fatal Attraction: Sex and Avarice in Dosso Dossi's Jupiter and Semele*
Text by Beverly Brown.
Hardback catalogue, 84 pages, 46 colour plates and 26 black and white illustrations.
£20 or $25 + p. & p.

2015 *Juan de Sevilla*
Text by Judith Sobre.
82 pages, 24 colour plates and 4 black and white illustrations.
£20 or $25 + p. & p.

2015 *Blasco de Grañén*
Texts by Judith Sobre, Nuria Ortiz Valero and Josep Maria Gudiol i Ricart.
96 pages, 26 colour plates and 7 black and white illustrations.
£20 or $25 + p. & p.

2015 *Paris Bordon: A 'Bella' with a Mirror: Vanitas, Virtue or Vice?*
Text by Peter Humfrey.
32 pages, 11 colour plates and 5 black and white illustrations.
£10 or $15 + p. & p.

2016 *Gustave Courbet*
Text by James H. Rubin
72 pages and 60 colour illustrations.
£20 or $25 + p. & p.

2017 *Guido Reni*
Texts by Patrick Matthiesen & D. Stephen Pepper
76 pages and 58 illustrations
£20 or $25 + p. & p. (scarce)

2018 *Jacob Jordaens: Homer, Hesiod & Aesop: Myth, Fable & Basic Instincts*
 Text by Gregory Martin, Patrick Matthiesen and Jeanne Teston.
 78 pages, 40 colours illustrations and 12 black and white illustrations.
 £20 or $25 + p. & p.

2019 *Sir Edwin Landseer. 'Living Life Boats', Edwin Landseer's Alpine Mastiffs & A rescue in the alps.*
 Texts by David Blayney Brown, Richard Ormond and Patrick Matthiesen.
 90 pages, 38 colour illustrations and 29 black and white illustrations.
 £20 or $25 + p. & p.

2020 *Artemisia Gentileschi – A Venetian Lucretia*
 Texts by Patrick Matthiesen & Jesse Locker.
 120 pages, 108 illustrations.
 £25 or $35 + p. & p.

2021 *Marie-Guillermine Benoist- 'Les Adieux de Psyché'*
 Texts by Guy Stair Sainty and Patrick Matthiesen.
 90 pages, 54 colour illustrations.
 £25 or $30 + p. & p.

2022 *Ribera-A Roman Philosopher- The Optics of an Old Tatterdemalion Dandy*
 Texts by Jacob Willer and Patrick Matthiesen.
 56 pages, 34 colour illustrations.
 £25 or $30 + p. & p.

2022 *Eeckhout - Sarah Returned to Abraham*
 Texts by Volker Manuth.
 24 pages, 10 colour illustrations.
 £10 or $15 + p. & p.

READER'S NOTES

MATTHIESEN

EXPERTS, AGENTS, APPRAISERS AND DEALERS IN
EUROPEAN PAINTINGS
FROM THE FOURTEENTH TO THE NINETEENTH CENTURIES